Laura Anderson Barbata:
Singing Leaf

September 9 – October 28, 2023

Marlborough Gallery
545 West 25th Street
New York, NY 10001
+ 1 212 541 4900
marlboroughnewyork.com

Associated Galleries

Marlborough Fine Art London
6 Albemarle Street
London W1S 4BY
+ 44 (0) 20 7629 5161
marlboroughgallerylondon.com

Galería Marlborough Madrid
Orfila, 5
28010 Madrid, Spain
+34 91 319 1414

Galería Marlborough Barcelona
Enric Granados, 68
08008 Barcelona, Spain
+34 934 674 454
galeriamarlborough.com

Marlborough

4

Introduction

We are fortunate and proud to present the work of Laura Anderson Barbata. *Singing Leaf* comprises over three decades of the artist's work and articulates, through various anchoring objects, beautiful instances of polyphony and reciprocity.

This exhibition gathers many traditions, voices, and communities that are empowered by the artist's humble, yet expansive, definition of authorship. Every page of this catalogue, as every work selected for this exhibition, carries the artist's nearly tacit approach to collaboration, which has brought forth the best work from each member of the gallery's team.

We would like to thank Edward J. Sullivan and Madeline Murphy Turner, both of whom contributed texts to this book, for their unwavering support and scholarship. We are deeply appreciative to Cuauhtémoc Medina and Museo Universitario Arte Contemporáneo for generously lending to the exhibition one of the artist's seminal self-portraits.

Lastly, I would like to express my gratitude to Alexa Burzinski and Nicole Sisti for orchestrating every aspect of this ambitious project.

Sebastian Sarmiento
Director

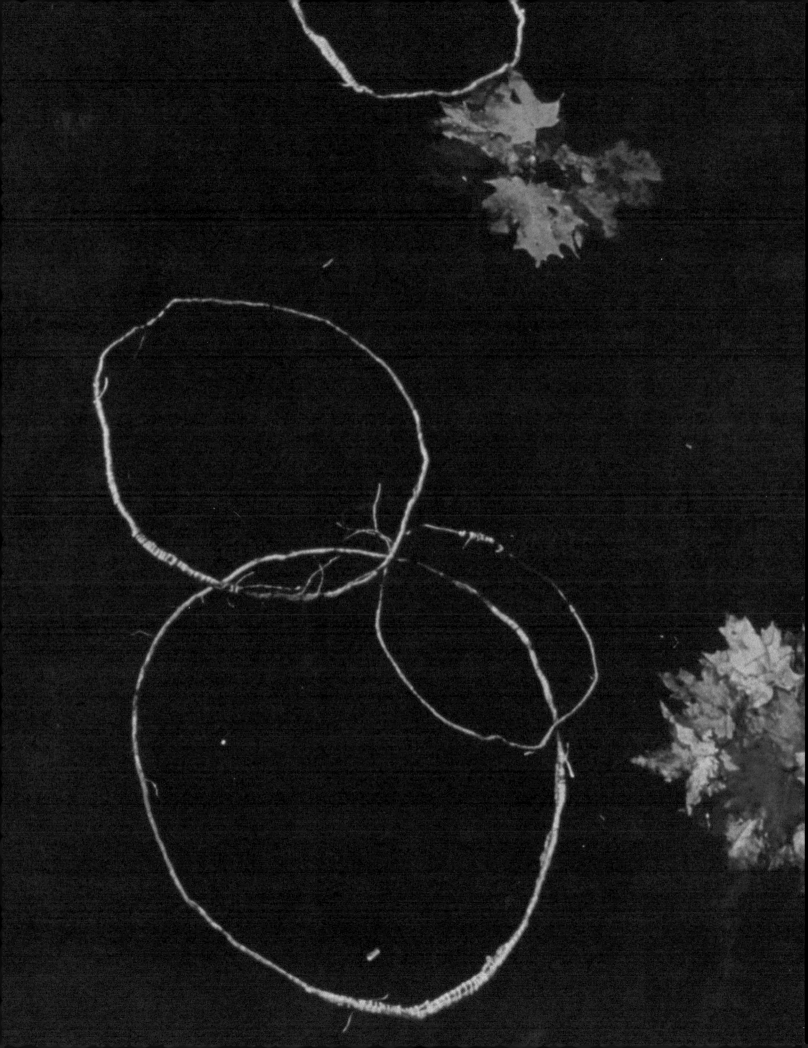

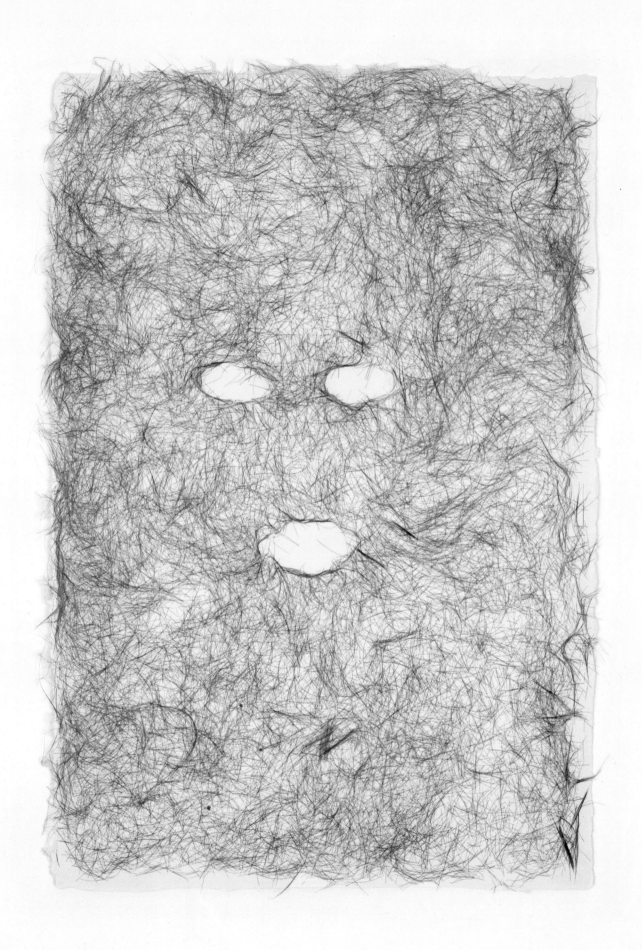

Laura Anderson Barbata:
Art, Activism, and Pedagogy:
A Personal Homage

Asked to write an essay about Laura Anderson Barbata for her retrospective exhibition, I am obliged to ponder the multiple and always felicitous meanings and circumstances of our personal and professional relationship that has endured for well over thirty years. As I wrote over ten years ago in the book *Transcommunality: Interventions and Collaborations in Stilt Dancing Communities* (Madrid: Turner, 2012), I knew of Laura's work in the late 1980s and wished to include it in an exhibition for which I served as curator. That show was called *La mujer en México / Women in Mexico* and it was presented at the National Academy of Design in New York in the fall of 1990. There had never been an exhibition focusing solely on twentieth-century Mexican women artists and I was privileged to collaborate, in the form of a catalogue text, with my colleague Linda Nochlin, the great and now sorely-missed art historian who brought the field of feminist art historical studies in existence with, among many other texts, her landmark essay "Why Have There Been No Great Women Artists" first published in 1971. The exhibition later traveled to Mexico City, Monterrey, and Liège, Belgium. I first met Laura in her Mexico City studio in late 1988 and loved the work I saw there. This included a selection of large-scale graphic and ink drawings from her series known as *Orígenes* and *Lo sagrado y lo profano*, groups of work that she exhibited in solo and group shows in Mexico City and Houston. These images

gave me a feeling of observing a cosmic germination, not just of seeds, but of earthly forces, telluric potencies that seeped into our collective consciousness. I chose some of these images for the *Women in Mexico* exhibition and have happily lived with one of her monumental drawings for many years. At least one work related to the late 1980s pieces that originally impressed me is present in the current exhibition. The 1996 *El porqué de las cosas* (The 'Why' of things) [p. 43] juxtaposes delicacy against strength, a trait very common throughout the artist's extremely varied and prolific production. It pairs the thinnest form of paper—rice paper—with a vigorous, even muscular approach to image-making by her use of definitive shapes created by an emphatic application of charcoal, oil stick, and wax.

Laura Anderson Barbata's art that initially attracted me so many years ago in Mexico City represented, in addition, a first phase of her intense dedication to paper—a medium that she has consistently employed throughout her career. In the 1990s Laura began an association with Dieu Donné studios in New York, well known for their support of their promotion of works on paper and support of experimental artists in the field of that medium. In fact, Laura's exhibiting career had begun with a 1986 prize for her drawings in Mexico City. In the following paragraphs I refer to her collaborations with the Yanomami, Ye´Kuana, and Piaroa Indigenous peoples in the Venezuelan Amazon Rainforest, that were essentially experiences primarily based on her work with the communities in the form of papermaking.

[1] *Julia Pastrana, Portrait*, 2012
 abaca and human hair on handmade pigmented cotton linter paper,
 variation from a series of 11; 18 × 12 in. / 45.7 × 30.5 cm

In the 2023 exhibition *Chosen Memories* at the Museum of Modern Art, a series of photographs taken by Laura were presented to document her work, during the decade of the 1990s, with the Yanomami, Ye´Kuana, and Piaroa Indigenous peoples in Venezuela. Obtaining the government permissions to enter this closed territory on the edge of the Orinoco River, in the Amazon Rainforest, was a difficult and tedious process, but once achieved the artist made this part of South America a temporary home over the course of more than a decade. The reasons for her sojourns to the Amazon were varied. She understood that over the course of the past century there had been various incursions into the territory of the Yanomami, Ye´Kuana, and Piaroa by gold prospectors as well as Catholic missionaries, including Jesuits and Salesians, and the Christian evangelical group called the New Tribes Mission, based in Florida. In my numerous conversations with Laura after her return from her trips to the Amazon, I understood that the thing that most affected her was the realization that such proselyting projects had intended to obliterate the Yanomami, Ye´Kuana, and Piaroa's mythical pasts and their memories of ancestral customs and rituals that had been handed down via oral traditions from generation to generation. What Laura proposed to do was to enter these communities with humility, proposing a series of give-and-take interchanges that afforded all parties to live among and learn from one another. What was specifically documented in the MoMA show was her proposal to teach papermaking to the local Yanomami group with whom she was living (one of approximately 250 villages in a territory that straddles Venezuela and Brazil) in exchange for their knowledge of how to construct a canoe from wood.

The results of the relationships between Laura and the Yanomami, Ye´Kuana, and Piaroa were extraordinary. In so far as her own work was concerned, it had the effect of creating a distinct chapter in her ever-expanding repertoire of thematic concerns and experimentation with what were for her new materials but were long-used materials for her Amazonian interlocutors.

In the exhibition at Marlborough that occasioned this essay, there are numerous testimonies to her interaction with the Yanomami, Ye´Kuana, and Piaroa, including the *Autorretrato* [p. 18] in the form of a wooden canoe. This 1994/98 work thus becomes a personal monument to the collaborative relationship with the Ye´Kuana in

particular. One might be excused for confusion in understanding the meaning of this work as the subject is a wooden canoe held by a man standing behind it. It is far from being a conventional self-portrait. This photo is an integral testimony to the artist's work and stands as a metaphor for the type of integration of Laura within the fabric of the Amazonian society with which she spent so much time in the 1990s. In it her own image is identified with the river-going vessel whose materiality functioned as the object of exchange for Laura's own knowledge of papermaking and block printing. Thus, she, in effect, connects her self-image directly with her presence among those people whom she was instructing.

Nonetheless, it was far from a one-sided connection. Also included in *Chosen Memories* was a book that was made in 2000—an account, on paper from local fibers—of the creation of a *shapono* (a communal house that is an integral part of Yanomami society) that grew out of the workshops that Laura offered the Yanomami on papermaking [pp. 50-55]. Eventually this collective industry resulted in the creation of an organized paper workshop, headed by a now well-recognized Yanomami Indigenous artist Sheroanawe Hakihiiwe who had learned from Laura. (His work was exhibited in the 2022 Venice Biennale).

My principal point in discussing the significance of Laura Anderson Barbata's collaborations with the Yanomami, Ye´Kuana, and Piaroa concerns not only the achievement of an artistic dialogue and the creation on the part of both the Mexican artist and the Indigenous creators of their own histories via books and drawings. I am equally interested in considering the evolution and flowering of this symbiotic relationship as a performative act of deep artistic, as well as political, ramifications. Laura became an agent of recuperation, on the part of these communities, of a central portion of their communal iconographies and pasts, while she, at the same time, entered proactive relationships with societies that are in constant danger of being fractured, symbolically and physically, from their essential forms of life. What Laura Anderson Barbata accomplishes is the antithesis of paternalistic (or perhaps "maternalistic" is a better term) neo-colonialism that has often afflicted other artists who find themselves within an alien or "different" situation and, instead of adapting their practice in a subtle and considered way, they appropriate from their new, "exotic"

cultural reference point. During her repeated periods of residence in the Amazon, Laura integrated herself and her artistic expression within the fabrics of the Yanomami, Ye´Kuana, and Piaroa societies and thus became a collaborator, a facilitator of resistance to officialdom and a subversive force of transformation and preservation.

One of the terms I employ in the title of this essay is "pedagogy." As a teacher (of art history at New York University), I am intensely interested in the "art and science" of imparting knowledge. Laura Anderson Barbata has been a fellow traveler in this realm for years. In a recent conversation Laura and I discussed the nature of her relationships with the Yanomami, Ye´Kuana, and Piaroa in Venezuela, as well as with various local communities in Oaxaca, Mexico, Trinidad and Tobago, and Brooklyn. It was in these locales that she has created what I call "actions" rather than "performances" with ten-foot-tall Jumbie stilt dancers whose presence at popular festivals is both a form of fascination and fear as their original meaning was connected to mortality. Laura stressed the fact that in these and other instances throughout her career she has preferred not the cliched life of a solitary artist working in her studio, but situations in which she enters a reciprocal relationship with other creators—be they of memories and past histories in the case of the Amazonian peoples—or the often-spontaneous enactments with the West-African-based art form of stilt dancing. I was riveted by the intensity of her discussion of the relationships she established with her collaborators as equals rather than students. Nonetheless, Laura's expertise in creating productive and cordial situations that then result in positive outcomes marks her practice as a pedagogical one in the deepest sense of the word. She teaches by enthusiastic example and conversation, allowing the creativity of those around her to blossom of its own accord.

The extraordinary story of the repatriation, through Laura's efforts, of the body of Julia Pastrana, a Mexican native of the state of Sinaloa, who lived a short but contested life (1834–1860) is so extraordinarily complex (and fascinating) that it could only be explained in great detail in a book length volume. And in fact, such a book exists. Entitled *The Eye of the Beholder: Julia Pastrana's Long Journey Home* (edited by Laura herself in collaboration with Donna Wingate and published in Seattle by Lucia/Marquand in 2017), it is a riveting story of

11

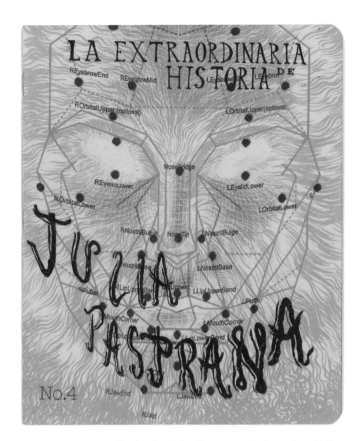

[2] Zine 4: *La Extraordinaria Historia de Julia Pastrana. The Beauty Issue*, 2017;
 24 pages, numbered ed. of 500; cover: Popset carboard;
 pages: recycled bond paper; Risograph; 8½ × 7 in. / 21.6 × 17.8 cm
 In collaboration with Erik Tlaseca.

persistence, diplomacy, cultural sensitivity, and bravery on the part of the artist and all the many people who assisted her in the almost ten-year long crusade. Pastrana was born with a rare physical syndrome that explained her hirsute appearance. She eventually made contact in Culiacán, capital of the state in which she was born, with teachers from whom she acquired her proficiency in several languages and her skills at dancing and singing. She ultimately met Theodore Lent, a businessman from the United States who took her on tour to various cities there and in Canada, and ultimately in Europe. Although much of her life story is still unknown, she evidently became an object of curiosity and celebration as much for her hairy body as for her theatrical talent. Dying in childbirth in Russia, Pastrana's body and that of her child with Lent were embalmed in Moscow and for years were on view in various circumstances as curiosities.

Laura first heard this strange story in 2003, after Pastrana's body had been integrated into the Schreiner Collection at the Department of Anatomy of the University of Oslo in Norway. She waged a vigorous campaign of repatriation that ended in 2012 with the arrival of

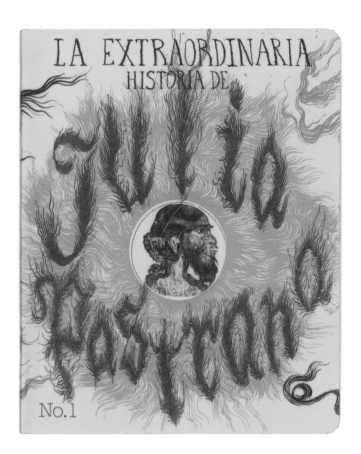

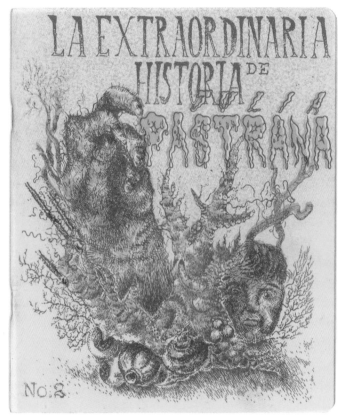

Zine 1: *La Extraordinaria Historia de Julia Pastrana.*
How can I get to know you?, 2015
20 pages, numbered ed. of 350 and numbered ed. of 80
cover: Popset carboard; pages: recycled bond paper; Risograph
8½ × 7 in. / 21.6 × 17.8 cm
In collaboration with Erik Tlaseca and Jesus Fajardo.

Zine 2: *La Extraordinaria Historia de Julia Pastrana.*
Eternity, 2016
22 pages including bonded double page with cut window,
numbered ed. of 489
cover: Popset carboard; pages: recycled bond paper; Risograph
8½ × 7 in. / 21.6 × 17.8 cm
In collaboration with Erik Tlaseca.

13

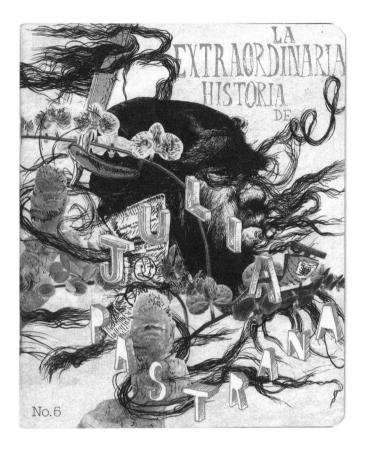

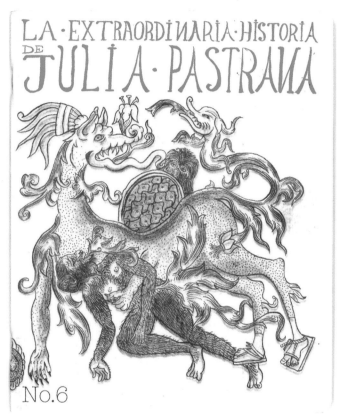

Zine 5: *La Extraordinaria Historia de Julia Pastrana.*
Hair, 2018
20 pages including foldout page, numbered ed. of 500
cover: Popset carboard; pages: recycled bond paper; Risograph
8½ × 7 in. / 21.6 × 17.8 cm
In collaboration with Erik Tlaseca.

Zine 6: *La Extraordinaria Historia de Julia Pastrana.*
Julia Pastranatzin Oyah ce Cahita Cihuatzintli, 2019
24 pages including 2 foldout pages, numbered ed. of 270
cover: Popset carboard; pages: recycled bond paper; Risograph
8½ × 7 in. / 21.6 × 17.8 cm
In collaboration with Erik Tlaseca.

Julia's casket in Culiacán and its subsequent burial, thus ending the cycle of ethical abuse and commodification of the singer's personality and corporeality that prefigures the mistreatment of women everywhere (and is especially virulent in the north of Mexico, with thousands of murdered and disappeared women in that part of the country). This story is relayed in detail in Laura's own essay in *The Eye of the Beholder*.

Some may consider Anderson Barbata's operation to recover the body of Julia Pastrana for a final resting place in Mexico an anthropological or a humanitarian project. Nonetheless, I wish to feature it as the core of the final series of comments in this essay. Laura performed a long-term social intervention that required a virtually herculean series of petitions, interviews, diplomatic inquiries, and interactions with governmental, university, and ecclesiastical authorities. Within the context of a multifaceted career, Laura's project represents a many years long involvement and meditation on innumerable philosophical themes. I would certainly categorize her project as a branch of situational aesthetics, a non-ownership form of artistic expression that responds to a cluster of circumstances brought about by the reaction to conditions on a personal or broader scale. These concepts were first articulated in a 1969 issue of *Studio International* magazine by British conceptual artist and philosopher, Victor Burgin. Indeed, what Laura Anderson Barbata has done within the parameters of her crusade does not fit within any pre-established framework as an art piece. Nonetheless, there are some concrete objects that she created as ancillary forms of *remembrance* and *memorialization* as well as *concretization*. A series of eight "portraits" made of hair applied to paper is one such artifact of commemoration [fig. 1; pp. 138-39]. These are evocative, indeed haunting, conjurings of Pastrana. Almost indescribable in photographic terms, they arouse the quintessence of their subject and serve as personifications of her bodily, if at the same time ghostly, presence.

After Pastrana's burial in the municipal cemetery in the town of Sinaloa de Leyva, Laura made a series of *frottages* or rubbings of her tombstone in a variety of colors [p. 137]. In addition, a handmade paperwork [p. 141], reminiscent of the type of *papel picado* that adorn the sites of popular gatherings, from weddings, to anniversaries, quinceñera parties, and funerals, celebrated the return of Pastrana to her homeland. Finally, Laura created a series

of "zines" or popular small-format, journal-like publications printed in large editions and dedicated not only to Pastrana, but to every conceivable connotation of her background, tragedy-filled life, death, post-mortem history, as well as the numerous ramifications of her death and repatriation [fig. 2; pp. 12-13]. These are all that I would call "additive projects"—or parts of the creative impulse that drove Laura Anderson Barbata to embark on her decade-long quest. They document and commemorate the events, yet they are subordinate to the essential altruistic and deeply political implications of the action itself.

Edward J. Sullivan is the Helen Gould Shepard Professor of Art History at New York University. He has written and curated numerous books and exhibitions on nineteenth- and twentieth-century art of the Americas and the Iberian Peninsula.

Julia Pastrana's casket entering the cemetery for burial,
Sinaloa de Leyva, Mexico, 2013.
Photo: Carlos Barrera

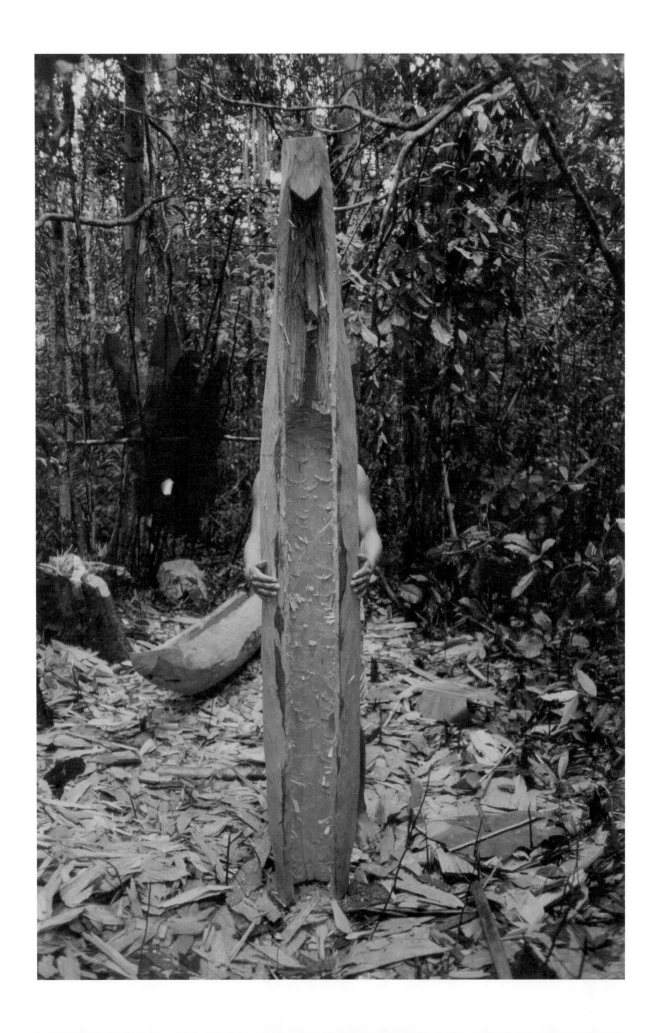

Above and Below:
Embodied Knowledge in the Work of
Laura Anderson Barbata

For only through the body, through the pulling of flesh, can the human soul be transformed. And for images, words, stories to have this transformative power, they must arise from the human body—flesh and bone—and from the Earth's body—stone, sky, liquid, soil.[1] – Gloria Anzaldúa

19 In 1994, Laura Anderson Barbata created the photographic self-portrait, *Autorretrato* (1994/98) [fig. 1]. The chromogenic print depicts a wooden canoe in the process of being formed, held upright by a figure whose arms and feet peek from behind as he supports the structure. The image is set in a clearing in the Venezuelan Amazon, where Anderson Barbata frequently traveled during the 1990s. The greenery of the surrounding flora is underscored by the piles of bark scattered across the forest floor, which have been stripped from felled trees to build the canoe. In the background, another soon-to-be-completed vessel lays on the ground next to a stump, presumably the origin of the wooden dugout. While the photograph is filled with these riveting details, Anderson Barbata's likeness is nowhere to be found despite the work's title.

In fact, in *Autorretrato*, Anderson Barbata is behind the camera, and the figure holding up the vessel is Enrique Ortiz, a Ye'kuana man from a family of expert canoe builders in Culebra, who offered to teach Anderson Barbata the strenuous skill of canoe building during one of her many trips to their village in the 1990s.[2] She took the photograph as she was in the middle of making her first canoe. Although the image does not directly show the artist, the canoe provides an alternative form of self-representation. Here, Anderson Barbata's sense of identity is reflected not in her physical features, but in her labor, relationships with others, and what I will refer to as embodied knowledge.

Spanning more than four decades, Anderson Barbata's career has produced artworks that range in medium, size, and content. When I first met the artist in 2014, she was organizing one of her large-scale interventions with stilt dancers from Brooklyn and Oaxaca, an endeavor that consists of dozens of participants and infinite moving parts. More recently, I have become captivated by the small-scale drawings on wax and handmade paper that she made in the early 1990s. Her work is unpredictable in this sense, taking on forms and scales that may seem disconnected but are ultimately unified by an exploration of knowledge and perception that come from the body. By positioning the corporeal rather than the mind as the center of understanding, communication, and exchange, the artist challenges the deeply ingrained ontologies of colonialism that have perforated the Americas since Columbus's arrival. In doing so, she underscores colonialism's violent legacies, diagnosing how they live on today in mechanisms of oppression.

Embodied knowledge defies the Cartesian split between mind and body that governs Enlightenment philosophy and its contemporary remnants. The impact of this duality is evidenced in scientific methods of class-

[1] *Autorretrato*, 1994/98
 C-print, ed. of 3 + 2 AP; 40 × 30 in. / 101.6 × 76.2 cm

ification that divide humans into distinct categories of race, gender, class, and even human. Feminist scholar Laura L. Ellingson articulates the possibilities afforded by embodied knowledge, arguing that it is "sensory; it highlights smell, touch, and taste as well as more commonly noted sights and sounds. Knowledge grounded in bodily experience encompasses uncertainty, ambiguity, and messiness in everyday life, eschewing sanitized detached measurement of discrete variables."[3] Anderson Barbata uses embodied knowledge as a mode of decolonial practice, which, as Walter Mignolo and Catherine E. Walsh propose, "aim to delink from the epistemic assumptions common to all the areas of knowledge established in the Western world since the European Renaissance and through the European Enlightenment."[4] In other words, decolonial thinking and doing, in the context of Anderson Barbata's work, completely unravels the beliefs that Western society has constructed over the past millennium.

SELF-PORTRAITS

Since beginning her career, and especially her first trip to the Venezuelan Amazon in 1992, Anderson Barbata has committed her practice to reworking perception. By 1994, she was living between New York City and Mexico City while regularly returning to Mahekototeri and its nearby villages in the Amazon. During a stay in downtown Manhattan, she began to work on her series of headless self-portraits, first *Autorretrato (Primera parte)* (1996) [pp. 72-73] and later *El viaje (Autorretrato)* (1996) [pp. 74-75]. The former is a sculptural installation that features a small wax figure whose head, from the collarbone and above, has been cleanly removed. Clothed in a dress, she is placed mid-passage over a bridge made of rattan and rope, which is suspended between two points on the ceiling. As with the photograph discussed at the start of this text, *Autorretrato (Primera parte)* is a self-portrait void of a face. "This is not a portrait of her physical features, but one that emanates from the heart," the artist Irvin Tepper succinctly summarized in 1998.[5]

Anderson Barbata explored the motif of the bridge in earlier self-depictions, such as a photograph from the mid-1990s where she stands still and erect on her way across a bridge in the high Orinoco territory of the Amazon. Nevertheless, *Autorretrato (Primera parte)* is the first self-portrait in which the artist completely eliminates her head, rejecting the need to illustrate herself with her likeness. In a conversation with the artist in 2021, she reflects on her personal and artistic development at the time she began the headless self-portraits:

"I understood who I was and what I was experiencing: that I cross a bridge, my life, without a head because what guides me is not my head nor my eyes, but the interior, which has its own way of seeing and its own way of thinking, and that way of seeing and thinking is going to ensure that I do not fall from the bridge, that I arrive to the other side without falling. I understood that to be able to *see* the world, I had to remove my head."[6]

The figure on the bridge also has roots in Anderson Barbata's personal history. As a girl growing up in a country where Catholic imagery is intrinsic to daily life, the artist received a prayer card depicting the Ángel de la Guarda (Guardian Angel), similar to one depicted on an early twentieth-century German postcard [fig. 2]. This familiar icon portrays a girl guiding her younger brother as they cross a bridge, the ethereal Guardian Angel hovering above as she protects their path. The image simultaneously intrigued and terrified the artist. The eldest of three sisters, Anderson Barbata interpreted it to symbolize her responsibility for her siblings. Nevertheless, it also instilled the belief that such responsibility was entirely hers; she could not rely on a heavenly being for guidance. This critical stance towards conversion tactics would emerge prominently in her artwork, especially in her installations of the mid-1990s and headless Virgins of the early 2000s.

Before addressing the artist's examination of religious structures, I would like to linger on the bridge motif and its ties to identity, the body, and decolonial thinking through the work of the radical Chicana feminist scholar Gloria Anzaldúa, whom I cite at the start of this text. In 1981, Anzaldúa and Chicana feminist writer Cherríe Moraga published *This Bridge Called My Back: Writings by Radical Women of Color*. In the preface to the first edition, Moraga articulates the painful racism and classism she faced within white feminism. She asks how she and her fellow feminists of color can fight back to undo the violence that Eurocentrism has inflicted on them: "How can we—this time—not use our bodies to be thrown over a river of tormented history to bridge the gap?"[7] In an act of poetic circularity, in 2022, Anderson Barbata contributed to *A Love Letter to This Bridge Called My Back*, an hom-

age to Moraga and Anzaldúa's original publication. The new book includes the script for *The Eye of the Beholder*, an experimental performance that Anderson Barbata realizes under the umbrella of the Julia Pastrana project, which Edward J. Sullivan beautifully elaborates on in his essay for this catalogue. During the performance, Anderson Barbata leads the public through exercises to practice shutting down their eye-brain responses, compelling them to see with their heart as an alternative.[8]

In 2012, the artist returned to making headless self-portraits with a series of multi-layered collages on handmade paper. She executed works such as *Autorretrato urbano* (2012) [p. 71] and *Autorretrato con mezcal* (2012) [p. 67] at a moment when she was living primarily in Mexico City. The latter shows the artist's now recognizable headless self-portrait suspended between skyscrapers that tilt haphazardly around her, reflecting the sensation of living in a metropolis where earthquakes are routine. In the air soar cutouts of dogs, stemware, bottles, and flames and, above the space where her head would be, a multipronged crown. Composed of two pieces of paper, one transparent and overlaid on top of the other, the

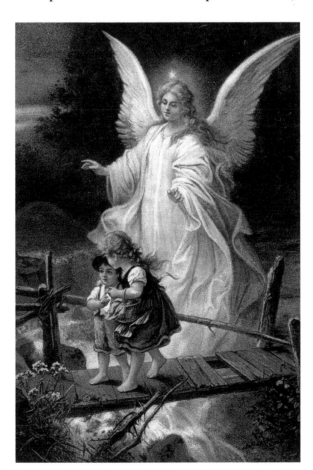

[2] Card showing Guardian Angel by Fridolin Leiber, 1900

work draws from *papel amate* (bark paper) and *papel picado* (perforated paper), contemporary practices that have roots in Otomí religious and cultural celebrations.[9] Working with this tradition in mind, while bringing her own extensive knowledge of papermaking to bear, Anderson Barbata creates an offering to the chaotic capital where she was born and lived.

Recently, the artist has united her headless self-portraits with her profound expertise in textiles. In 2023, she finished *Self-Portrait (With Cochinilla)* [p. 77], a hand-dyed silk jacquard tapestry made from cochineal, turmeric, iron, indigo, and rose petals. These new works are outgrowths of her ongoing project *Intervention: Cochineal Red*, a call to action to protect and support all individuals who identify as women, which she began working on during her residency at the Isabella Stewart Gardner Museum in Boston in 2017. The project involves a profound exploration of the history of cochineal dye. Through her research, Anderson Barbata analyzes the red pigment's critical role in the colonial economy of circum-Atlantic trade: during the first years of the Conquest, the dye was introduced into Europe from Mexico, where it had long been used. Additionally, as the artist confirms, gender-based violence is inevitably part of cochineal: the natural colorant can only be obtained by pulverizing the bodies of the *Dactylopius coccus*, a female insect native to tropical and subtropical regions.

The 2023 large-scale self-portraits continue the investigation begun in *Intervention: Cochineal Red* by incorporating cochineal as well as spices, herbs, and flowers to engage with a long history of women (often persecuted as witches) who used these materials to cure and heal the body. Relatedly, the materials on silk, which will alter in color over time, create the visual sensation of skin that has been bruised or scratched. Thus, the artist unveils the longstanding connections between the body, coloniality, and gender-based violence by weaving these metaphorical threads through her headless self-portraits.

THE VIRGIN MARY

In title, the 2023 self-portraits claim to be representations of the artist. However, through their multidimensional points of reference, they simultaneously address the struggles of women across the globe. Relatedly, I would like to fold into the conversation a body of work

[3] Image from *The Discovery of Guiana* by Sir Walter Raleigh, 1612.
University of Virginia, Special Collections, McGregor Grant Collection

that is not self-portraiture yet uses the headless motif to examine and critique evangelization. In the 1990s, while spending extended periods collaborating with the Yanomami, Ye´Kuana, and Piaroa, the artist perceived the prominent but also destructive role that Christianity had played in Latin America. She explains this shift in perception, "At that moment, I realized that I could not talk about what I was living and feeling in the Amazon without talking about the people and the social and political reality of the region. As a result, I began a more serious and critical investigation into processes of evangelization, both historical and contemporary, that the Yanomami, Ye´Kuana, and Piaroa and my own culture had experienced."[10] She created installations such as *Archive X* (1998) [pp. 59–61] and *Yo no soy digno de que vengas a mi, pero una palabra tuya bastará para sanar mi alma* (1996) [pp. 86–87], both of which critique Christianity's protagonism in the erasure of Indigenous languages, extending from colonization to the present. She also continued experimenting with the removal of the head to emphasize the body, this time with a vision toward the complexities of Catholicism in the Americas.

Consuelo* (2002) [pp. 94–95], for example, exploits the Virgin Mary as a figure that is simultaneously horrific and beautiful. An eight-minute looped video, it begins with an image of a bright blue sea and sky.[11] A small figure slowly emerges from the horizon line. As she approaches, she is decipherable as the Virgin Mary, cleanly decapitated from the collar bone up and swaying with open arms.

The music crescendos while she progressively occupies the entire screen. Once in the foreground, a golden wishbone emerges from her chest, instilling a sense of unease in the viewer, who becomes subsumed by her image. At the end of the video, she vanishes as the music cuts out, leaving an unsettling sense of her invisible presence (not so different from the sensation that Anderson Barbata had when first viewing the Guardian Angel prayer card). In her analysis of *Consuelo* for Anderson Barbata's 2003 exhibition, *Terra Incognita*, Ilona Katzew skillfully articulates the interweaving of attraction and dread that the video work exudes. She writes, "The piece may be interpreted as a poetic commentary on the evangelizing designs of some in the Amazon, of the seductive power of religion and the frightening results it can have. The fact that the Virgin is headless, like the artist's self-portraits, is significant. She, too, is guided by her heart as opposed to reason, but the love she embodies also contains the possibility of total extinction."[12] Even the video's name denotes this synchronized sensation of horror and pleasure: *consolar* (to console) is an action used when a situation cannot be remedied, and all that can be done is soothe the pain.

A related sculpture from 2006, also titled *Consuelo* [p. 93], takes a different physical form. What initially seems to be a religious figure subjected to an aggressive act of iconoclasm, the work is a sculpture of the headless Virgin Mary that Anderson Barbata commissioned to be carved from Linden Wood, and then cut off the head. Like the figure in the video, she is the Virgin of Miracles, indicated by her open arms, the earth she stands on, and the serpent she crushes. The artist chose to remove the Virgin Mary's head to liberate her from physical associations with age, gender, or beauty and to make her more relatable as a mother and woman. These expressions of empathy and criticism of the Virgin Mary expose many devotees' complex relationship with the mother of Jesus. For some, she is the holy mother; for others, she symbolizes an oppressive belief system. Especially across the Americas, she is beloved by many yet also embodies the violent processes of colonization that led to the extraction of Indigenous land and life.

Looking beyond Catholicism, Anderson Barbata has long been preoccupied with the various tactics that the Conquest used to divide and dehumanize. She is particularly marked by a sixteenth century engraving by Sir Walter Raleigh [fig. 3]. Published in Raleigh's *The*

22

Discovery of Guiana (1599), the image was used to barbarize Native persons and promote religious salvation through conversion. The engraving alleges to illustrate the Ewaiponoma people of Guyana, who are shown as headless men with eyes, noses, and mouths embedded in their chests. This image forms part of a much broader tradition of sixteenth- to eighteenth-century traveler artists, whose depictions of the Americas contributed to the racist perception of Indigenous people as "savages." As part of a larger Enlightenment project, these portrayals also sought to categorize and taxonomize humans, flora, and fauna, ultimately constructing the theory that Indigenous people were more aligned with unwieldy nature than rational humans. Speaking about the impact of Raleigh's engraving, especially on her interest in embodied experience, Anderson Barbata reveals, "I want to take ownership of this image. I *want* to unravel it, and find a different meaning for it. And it is that from the *center,* from the *chest and the heart,* where truth is *known and understood,* from this place, one can *truly see* the world."[13] Today, Raleigh's engraving is projected behind Anderson Barbata during her performance of *The Eye of the Beholder,* as she uses the image to decipher the construction of racism and gender-based violence in the modern world. At the same time, her references to Raleigh's image and the Virgin Mary across her practice undermine the passive acceptance of violent imagery by reformulating it in contexts that unveil their deeply ingrained biases.

RETRATO DE FAMILIA

Raleigh's engraving from *The Discovery of Guiana* is part of early modern traveler artists' penchant for illustrating and categorizing the "New World." Two centuries later, systems of classification through visual representation became increasingly applied to human beings. This is especially notable in *Casta* painting, a genre that circulated racial types throughout Mexico in the eighteenth-century [fig. 4]. The classification of races, according to Ilona Katzew in her definitive study of the genre, "became highly fashionable in the eighteenth century as scholars and lay people alike sought to explain why people differed in color and behavior."[14] Especially within debates on miscegenation in the Americas, Casta painting supplies a visual order to the obsession with genetics and lineage.

From 2011 to 2022, Anderson Barbata created *Retrato de familia* [fig. 5], a series of photographs in which

[4] Miguel Cabrera, *From Spaniard and Morisca, Albino Girl (De español y morisca, albina)*, 1763; oil on canvas; 51⅝ × 41⅜ in. / 131.1 × 105.1 cm Purchased with funds provided by Kelvin Davis in honor of the museum's 50th anniversary and partial gift of Christina Jones Janssen in honor of the Gregory and Harriet Jones Family, M.2014.223

she critiques the contemporary visual indexing of human types through a 1994 issue of the Mexican journal *Saber Ver: lo contemporáneo del arte.* Published as a special edition titled *La nación mexicana: retrato de familia* [The Mexican Nation: Family Portrait], the journal featured optimistic if not quixotic essays such as one by Silvio Zavala titled "México: Pluralidad Cultural, Convivencia Nacional" [Mexico: Cultural Plurality, National Coexistence], in which the historian lays out the diverse roots of Mexico's population.[15] The texts centered around the series of photographs *Retrato de familia: la nación mexicana,* which Lourdes Almeida took between 1992 and 1994 as she traveled across Mexico to document the nation's "diverse social mosaic," as the magazine describes her project.[16] While Almeida's photographs are accompanied by a nineteenth-century portrait of a wealthy European-descended family, the majority of the *Saber Ver* issue features her studies of Indigenous or Afro-Mexican families outside the nation's capital. In this sense, it re-enacts the strategies of Casta painting or even Raleigh's engraving in its desire to classify and exhibit humans who are non-white.

After encountering the journal, Anderson Barbata

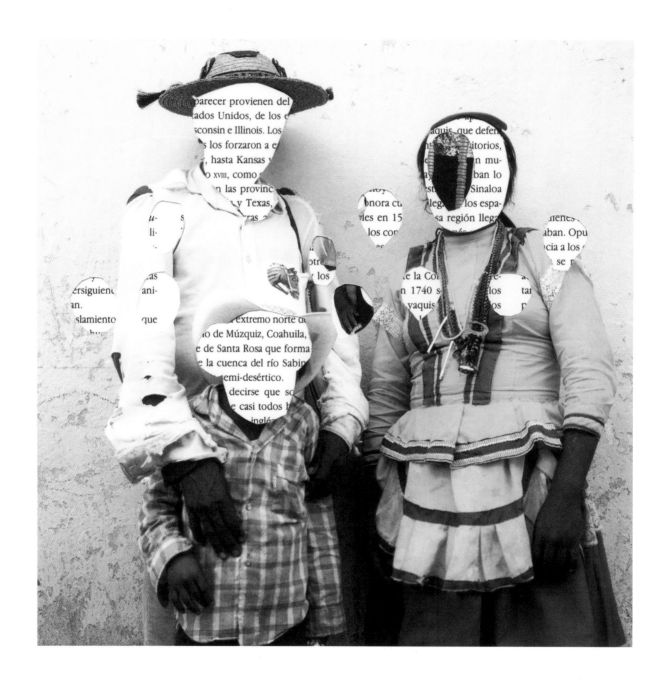

24

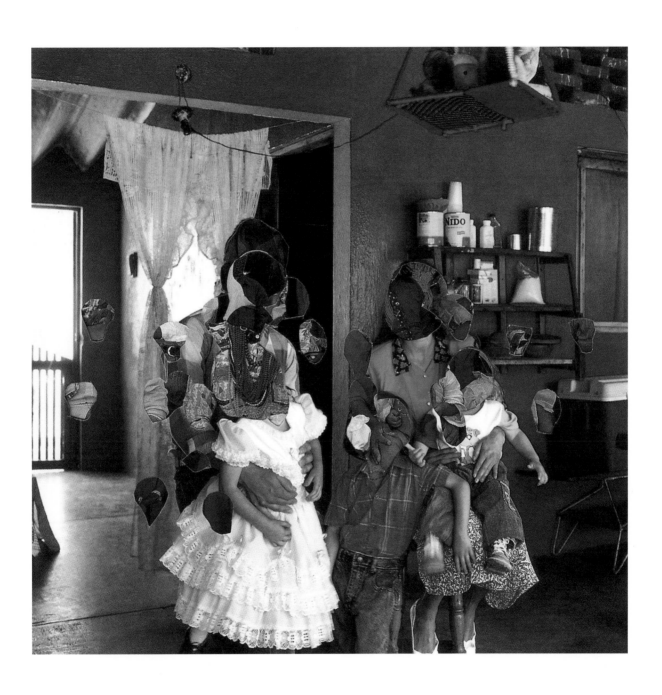

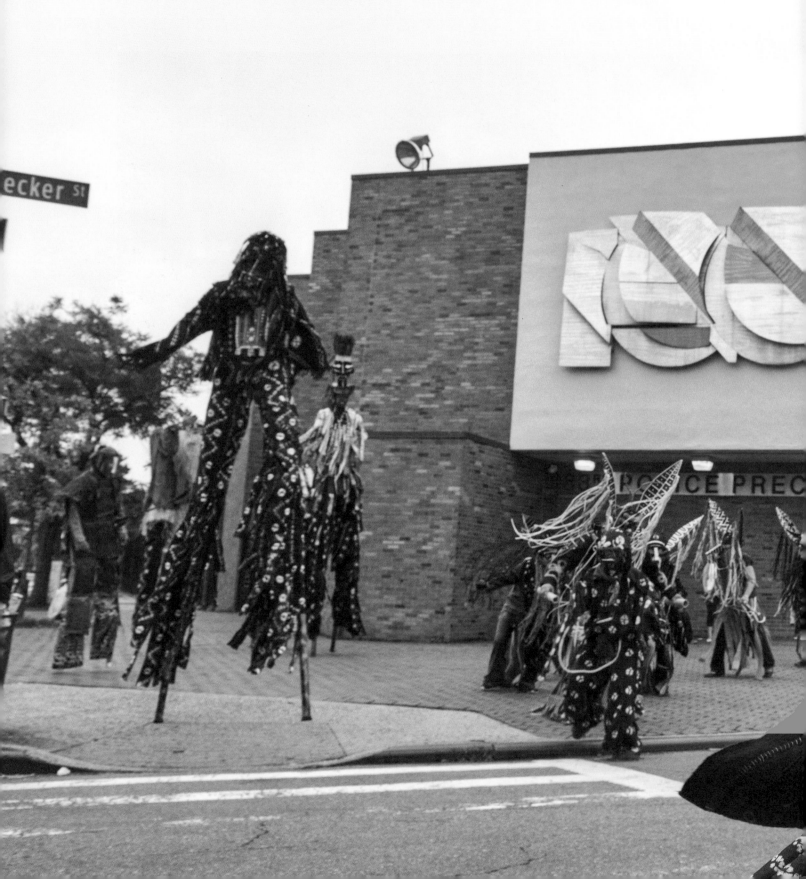

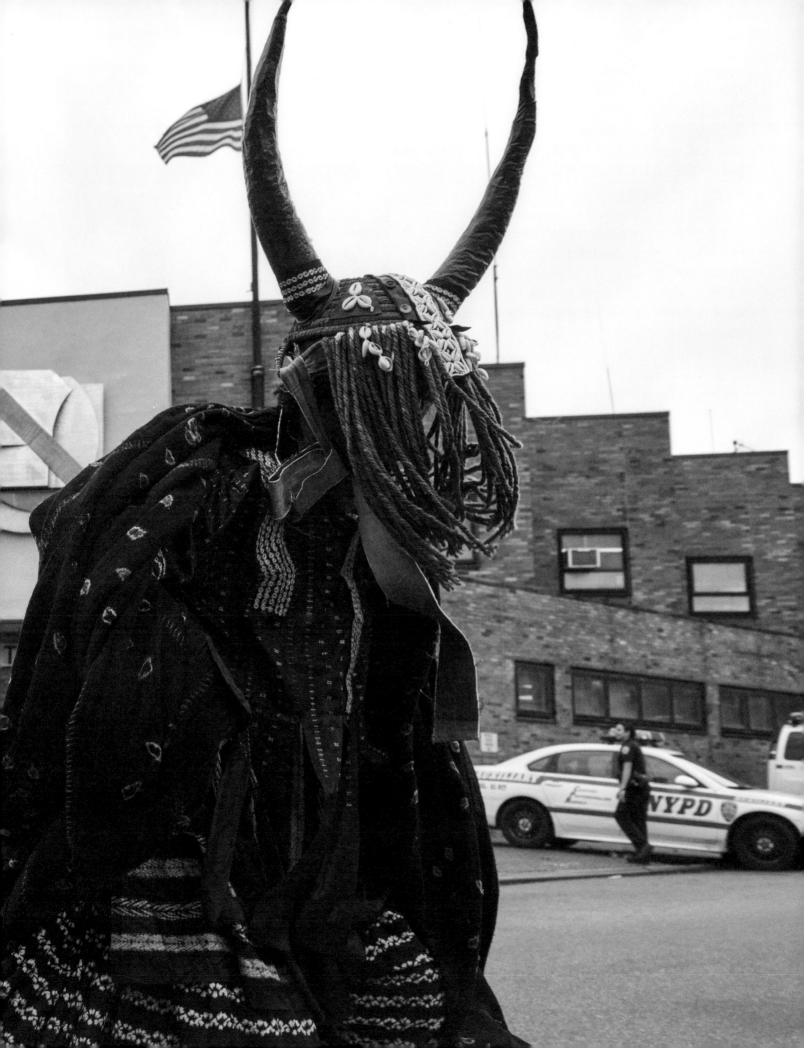

took time to go through it, physically cutting out the faces of each person. Similarly, in her earlier painting *Tlacaxipehualiztli* (1998) [p. 83], which refers to the Aztec annual festival of flaying and removing the heart of human sacrificial victims, she cut out the faces of anonymous portraits, replacing them with orchid leaves. However, with *Retrato de Familia*, she continued by photographing the pages, the portraits now chasms through which the following page's text and image seep. Her final photographs of the modified *Saber Ver* issue create a fissure that speaks to the impossibility of codifying humans. Meticulously erasing each figure's face prevents the viewer from feeling genuinely engaged with these superficial studies, hopefully provoking the question of what lies beyond their racial or ethnic appearance.

Almeida took the photographs in the early nineties, a moment of heightened identity politics, particularly given the quincentennial of Columbus's arrival to the Americas. At that time, in the arts, topics of personal identity became popular among artists such as Nahum B. Zenil or Julio Galán, who were searching for ways to explore their unique worlds rather than nationalist imagery. However, identity soon became enmeshed in national politics by way of the Partido Revolucionario Institucional (PRI), the political party that held uninterrupted power for over seven decades. As Olivier Debroise analyzes, at the time, the Mexican government, led by President Carlos Salinas, began to employ ethnicity, race, and gender to "soften its neoliberal program with 'signs of identity,'" utilizing the Mexican mestizo body to emphasize a territorial sense of belonging, a trope that the government had implemented since the Revolution.[17] It could be argued that *Saber Ver* is imbricated in this strategy. Published by the Mexican mass media corporation Televisa, *Saber Ver* describes Almeida's project in a jargon that echoes the fascination with classificatory multiculturalism: "This is how categorization begins to function in Almeida's portraiture, it is a classification that registers and offers specific micro universes, where portraits that fit into them are inserted based on an adequate complementary insertion with their attitudes, poses, and dresses."[18]

Several years before the issue of *Saber Ver* was released, Galán produced a painting that critiques the exploitation of southern Mexican identity by removing the central figure's face. His painting/montage *Tehuana*

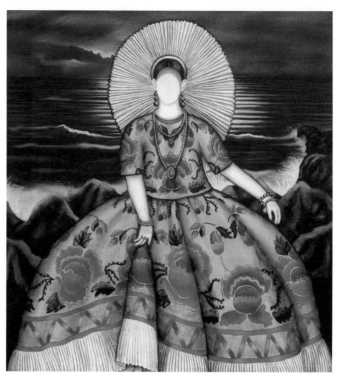

[7] Julio Galán, *Tehuana en el Istmo de Tehuantepec (Tehuana in the Isthmus of Tehuantepec)*, 1987; oil/acrylic/montage on canvas; 82 × 82 in. / 208.3 × 208.3 cm
Collection of Diane and Bruce Halle

en el Istmo de Tehuantepec (Tehuana in the Isthmus of Tehuantepec) (1987) [fig. 6] underscores the campy portrayal of the Tehuana, a culturally specific figure from Tehuantepec whose image has been commodified by Mexican nationalism. Excising her face from his painting, he turns her into a version of a carnival cutout.[19] However, while Galán's *Tehuana* and related works with cutout faces were ironic critiques of the betrayal of Mexican national culture, Anderson Barbata's removal of the figure's head is more a provocation to ask how we can understand ourselves and our culture by seeing with the heart rather than the eyes or mind.

INTERVENTIONS

Aside from removing the head, we also find that Anderson Barbata reorients perception by accentuating the body. This is prevalent in her long-term collaborations with stilt-dancing communities from Port of Spain, Trinidad; Oaxaca, Mexico; and Brooklyn, New York. For almost two decades, she has collaborated with the Brooklyn Jumbies (led by Najja Codrington and Ali Sylvester) whose practice is based in stilt-dancing traditions from Senegal. Together, the Brooklyn Jumbies and Anderson Barbata have organized large-scale

street interventions to draw attention to social injustices in the United States and abroad. In addition to the previously referenced *Intervention: Cochineal Red*, this series of works include *Intervention: Wall Street* (2011), *Intervention: Raphael Red* (2017), *Intervention: Ocean Blues* (2018), and *Intervention: Indigo* (2015/2020). *Indigo* [fig. 6] was initially presented in September 2015 by Anderson Barbata, the Brooklyn Jumbies, Chris Walker, and Jarana Beat in Bushwick, Brooklyn. Uniting performance, dance, music, textile arts, protest, and procession, the intervention is a call to action in response to the violence and murder of Black persons in the United States and beyond at the hands of the police.[20] The reference to the titular distinctive blue color comes from the dye's historical association with royalty, protection, and knowledge. To emphasize the pigment's many meanings, as the Jumbies, Anderson Barbata, and their collaborators proceeded through the streets of Bushwick, they donned Anderson Barbata's wearable sculptures, assembled from various indigo textiles she made and collected. Towering above passersby, the stilt-walking Jumbies reiterate Anderson Barbata's

29

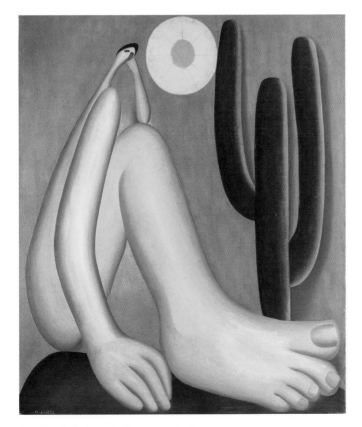

[6] Tarsila do Amaral, *Abaporu*, 1928; oil on canvas;
33⁷⁄₁₆ × 28¾ in. / 85 × 73 cm
Collection MALBA, Museo de Arte Latinoamericano de Buenos Aires
© Tarsila do Amaral Licenciamentos. Photo: Romulo Fialdini

focus on reworking perception away from the head and towards the body.

The emphasis on the corporeal over the head has a long history in the Americas, especially as a strategy to assert independence from European influence vis-à-vis decolonial forms of knowledge. Writing about Brazilian modernist poet Oswald de Andrade's groundbreaking "Manifesto Antropófago" [Anthropophagite Manifesto] (1928) and *Abaporú* (1928) [fig. 8], Tarsila do Amaral's painting that inspired it, scholar Gonzalo Aguilar argues that, in their search for a uniquely Brazilian identity, the writer and artist proposed a new body, one that "appears to attack the privilege given to the head in western tradition as much as the portrait as an element of identification."[21] Tarsila's *Abaporú*, which depicts a genderless figure with a massive leg firmly planted on the earth and minuscule head, rejects the hierarchy of the mind and the idea for the knowledge contained in the physical body. Looking up at the Brooklyn Jumbies or other stilt dancers, the perspective is not much different: legs and bodies visually consume the head. Despite its problems with racial essentialism, the *Manifesto Antropófago* nevertheless reveals the struggles of formulating identity in a modern, neocolonial world. It does so by challenging the dualities upon which the Eurocentric Western thought that characterizes coloniality and modernity are built.

Throughout *Laura Anderson Barbata: Singing Leaf*, we can see how Anderson Barbata's practice frequently dissolves the duality between body and mind. Each of her projects mentioned here reveal that knowledge is not solely the territory of the head but rather moves through and between bodies. With her headless self-portraits and Virgin Marys, *Retrato de familia*, and Interventions, the artist argues for the body as the center of understanding, meaning, and communication. She tries to teach her audiences new ways of perceiving, ways that, as Gloria Anzaldúa poses in the quote that begins this text, "arise from the human body."[22] In doing so, what may seem like a simple gesture of beheading unfolds new strategies to deconstruct racism, gender-based violence, and extractivism, mechanisms that colonial thinking and its legacies continue to exert in the twenty-first century.

Madeline Murphy Turner, Ph.D., is an art historian and curator based between the United States and Argentina.

1 Gloria Anzaldúa, *Borderlands/La Frontera*, second edition (San Francisco: Aunt Lute Books, 1999), 97.

2 In return, she taught members of the Ye'kuana, Piaroa, and the neighboring Yanomami in Platanal (Mahekototeri in Yanomami) how to make paper from natural fibers. For further details on Anderson Barbata's collaboration with the Ye'kuana, Yanomami, and Piaroa communities, see Laura Anderson Barbata, "Looking Back on 1992," *Latin American and Latinx Visual Culture* 2 no. 2 (2020).

3 Laura L. Ellingson, "Embodied Knowledge," in *The SAGE Encyclopedia of Qualitative Research Methods* (Thousand Oaks: SAGE Publications, 2008), 245.

4 Walter Mignolo and Catherine E. Walsh, *On Decoloniality: Concepts, Analytics, Praxis* (Durham, N.C.: Duke University Press, 2018), 106.

5 Irvin Tepper, *In the Order of Chaos*, Hilda Campillo, trans. (Austin: Austin Museum of Art, 1998), 6.

6 "*Entendí quién era yo y que estaba pasando. Que yo camino sobre un puente sin cabeza porque a mí lo que me guía no es mi cabeza ni mis ojos, sino el interior, que tiene su propia manera de ver y su propia manera de pensar y que esa manera de ver y de pensar va a cuidar que yo no me caiga de este puente y que yo llegue al otro lado sin caerme. Entonces entendí que yo, para poder ver el mundo, me tenía que quitar la cabeza*". Interview with Laura Anderson Barbata by Madeline Murphy Turner, 25th April 2020. Cited in Madeline Murphy Turner, "We a part of them: Laura Anderson Barbata and the disassembly of border regimes," *Burlington Contemporary* 4: Art from Latin America (June 2021). https://doi.org/10.31452/bcj4.barbata.turner

7 Cherrie Moraga, "La Jornada," in *This Bridge Called My Back*, Cherrie Moraga and Gloria Anzaldúa, eds., fourth edition (Albany: State University of New York Press, 2015), xxxvii.

8 Tamilla Woodard and Laura Anderson Barbata, "Julia Pastrana and the Eye of the Beholder," in *A Love Letter to This Bridge Called My Back*, Gloria J. Wilson, Joni B. Acuff, and Amelia M. Kraehe, eds. (Tucson: University of Arizon Press, 2022).

9 For more on *papel picado*, see César García, "El papel picado mexicano," *Confluencia* 6 no. 2 (Spring 1991): 177–79.

10 Interview with Laura Anderson Barbata by the author, May 27, 2023. "En ese momento, me doy cuenta que no puedo hablar de lo que estoy viviendo y sintiendo en las Amazonas sin hablar acerca de la gente y la realidad política y social de la zona. Entonces, empieza una investigación como mucha más seria y critica hacía procesos de evangelización, de conversión histórica y contemporánea, entre ellos y la mía." All translations are by the author unless otherwise noted.

11 *Consuelo* (2002) is designed to be shown in a church or a chapel and projected onto the statue of a saint or virgin set in a niche or shrine. It was first shown in the artist's solo exhibition *Terra Incognita* at the experimental art space Ex-Teresa in Mexico City.

12 Ilona Katzew, "Terra Incognita: Laura Anderson Barbata and the Amazon," in *Terra Incognita* (Mexico City: INBA/Ex Teresa Arte Actual, 2003), 45–46.

13 Interview with Laura Anderson Barbata by the author, May 27, 2023. Original emphasis.

14 Ilona Katzew, *Casta Painting: Images of Race in Eighteenth-Century Mexico* (New Haven: Yale University Press, 2004), 5.

15 *Saber Ver: La nación mexicana: retrato de familia* (Special Edition, June 1994).

16 Ibid.

17 Olivier Debroise, "I Want to Die," in *The Age of Discrepancies: Art and Visual Culture in Mexico* 1968 – 1997, Olivier Debroise and Cuauhtémoc Medina, eds. (Mexico City: UNAM, 2006), 279.

18 "Retrato familiar de Lourdes Almeida," in *Saber Ver*, 80. "Empieza a funcionar así, en la retratística de Almeida, la tipificación, esto es, la clasificación que registra y ofrece determinados microuniversos en donde están insertos los retratos que se acomodan en ellos a partir de una adecuada representación complementaria con sus actitudes, poses y vestidos..."

19 Teresa Eckmann, "Julio Galán and the Type: Fashioning a "Border" Aesthetic," in *Visual typologies from the early modern to the contemporary: local contexts and global practices*, Lynda Klich and Tara Zanardi, eds. (New York: Routledge, 2019).

20 In 2020, *Intervention: Indigo* was adapted for a Mexico City context with local communities as *Intervención: índigo CDMX*.

21 Gonzalo Aguilar, "Abaporu de Tarsila do Amaral: saberes del pie," in *Por una ciencia del vestigio errático (Ensayos sobre la antropofagia de Oswald de Andrade)* (Buenos Aires: Editora Grumo, 2010), 7. "parece atacar tanto el privilegio dado a la cabeza en la tradición occidental como al rostro en tanto elemento de identificación."

22 See endnote 1.

pp. 31, 32–33: *Memory is a Porous Archive*, 1994–2005/2023 (detail); 120 35mm slides from the Amazon, Trinidad and Tobago, Cuba, Boreal Canada, New York, and Mexico, vitrine, unique

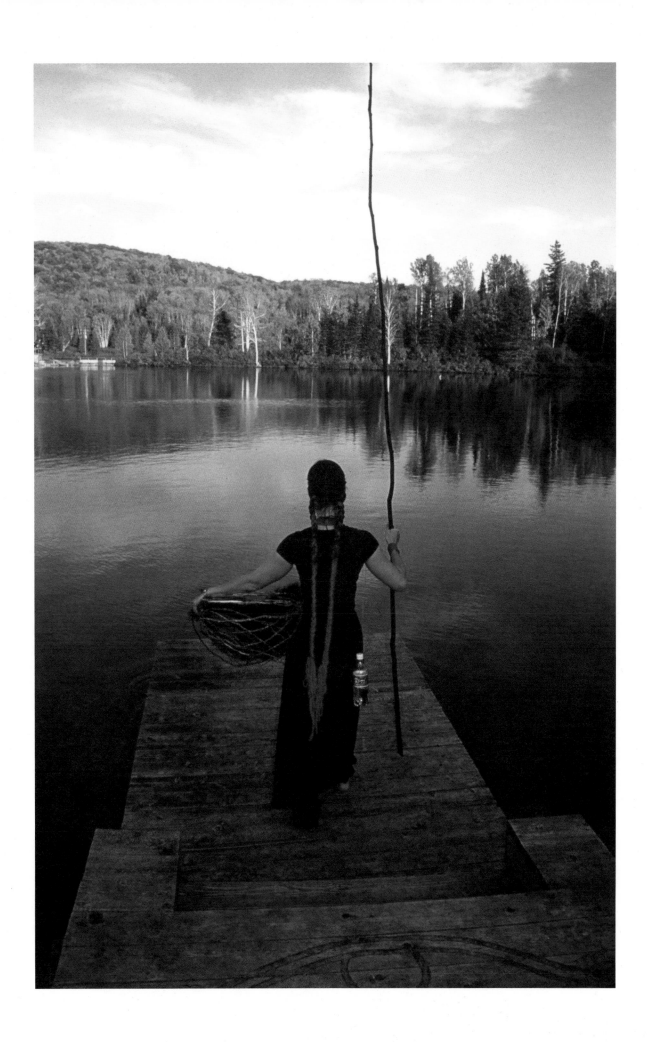

PLATES

Fruto a punto de madurar, 1994/2023
wood and gourds from the Amazon painted with natural dyes
and resins, honey wax, unique
30 × 9 × 10 in. / 76.2 × 22.9 × 25.4 cm

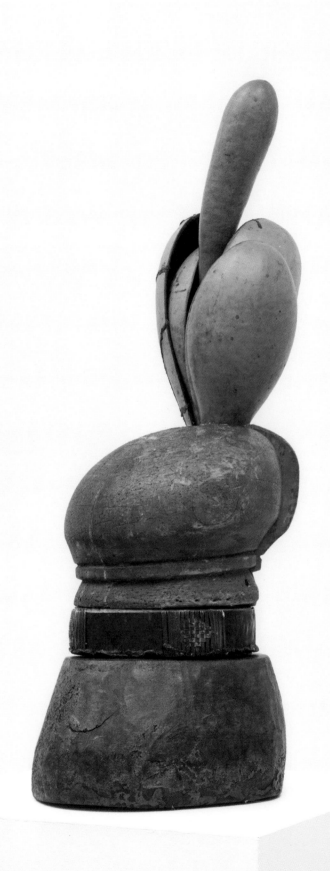

Antiguo luto, 1993
charcoal, graphite, and pastel on canvas
50½ × 58½ in. / 128.3 × 148.6 cm

39

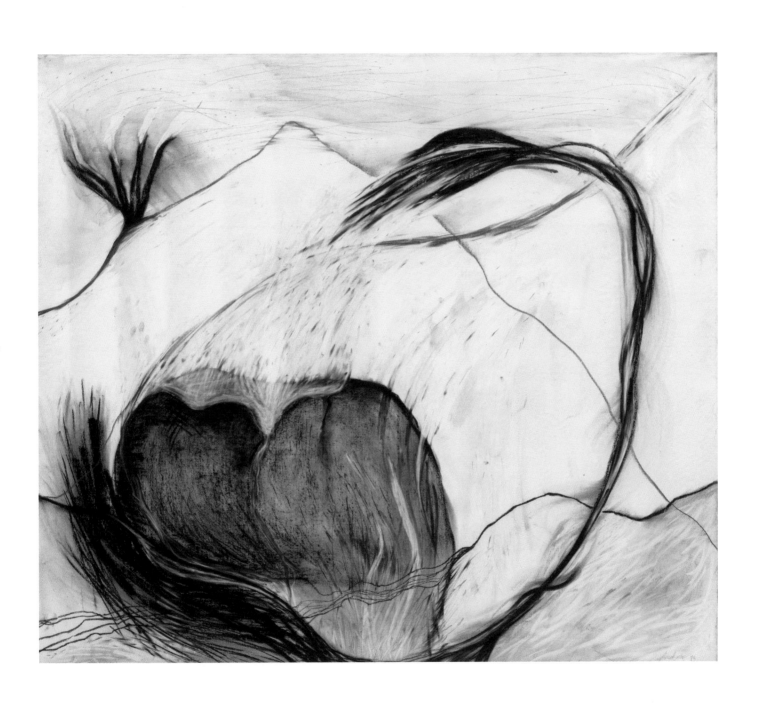

Planta mágica Kaahl, 1994
graphite, charcoal, and oil pastel on paper
68⅞ × 33½ in. / 174.9 × 85.1 cm

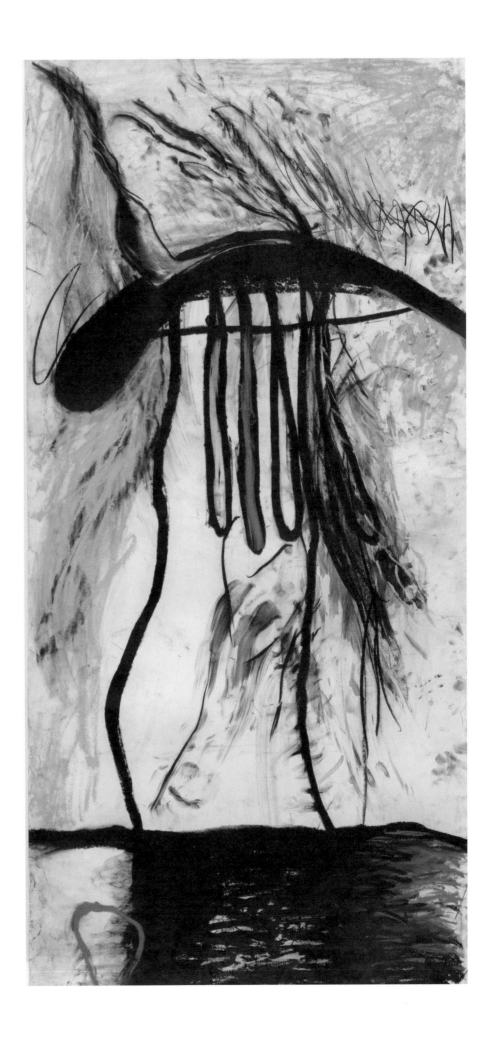

El porqué de las cosas, 1996
graphite, wax, and oil stick on rice paper
54½ × 27½ in. / 138.4 × 69.8 cm

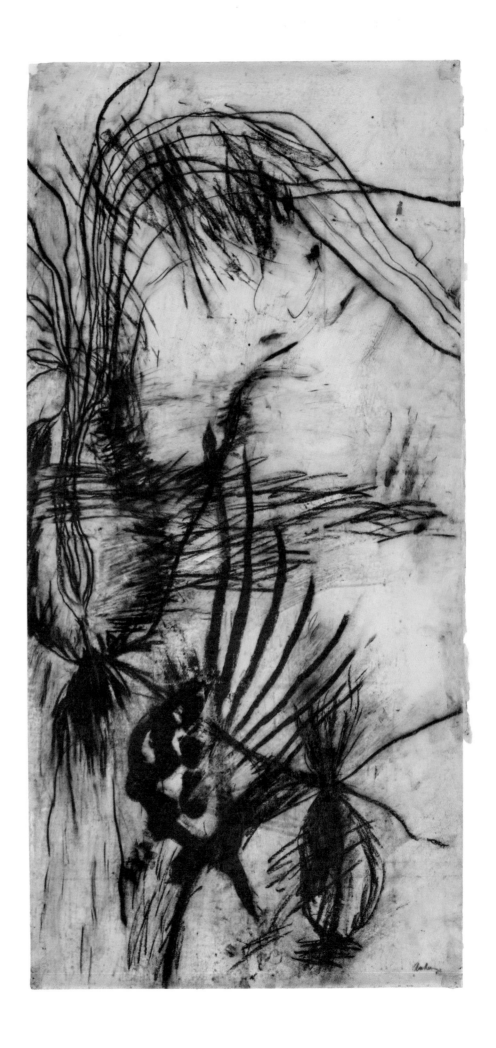

Mano maíz, 1996/2023
C-print, ed. of 3 + 2A P
30 × 45 in. / 76.2 × 114.3 cm

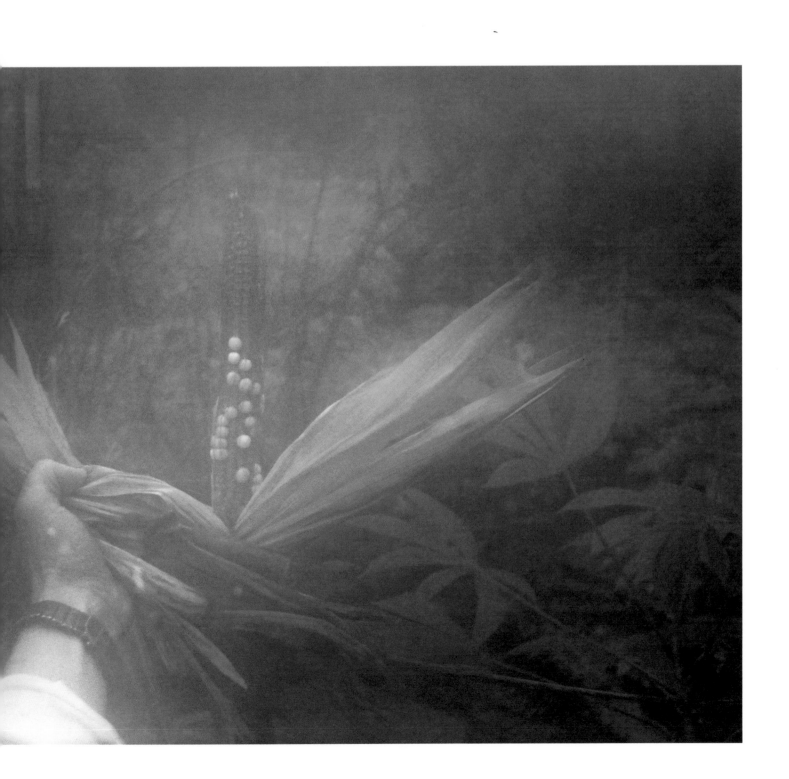

Carro. Piedra, 1996/2023
C-print, ed. of 3 + 2 AP
30 × 45 in. / 76.2 × 114.3 cm

Conejo, 1996/2023
C-print, ed. of 3 + 2 AP
30 × 45 in. / 76.2 × 114.3 cm

pp. 50–51: Laura Anderson Barbata experimenting
with paper-drying techniques in the Venezuelan Amazon (1994).

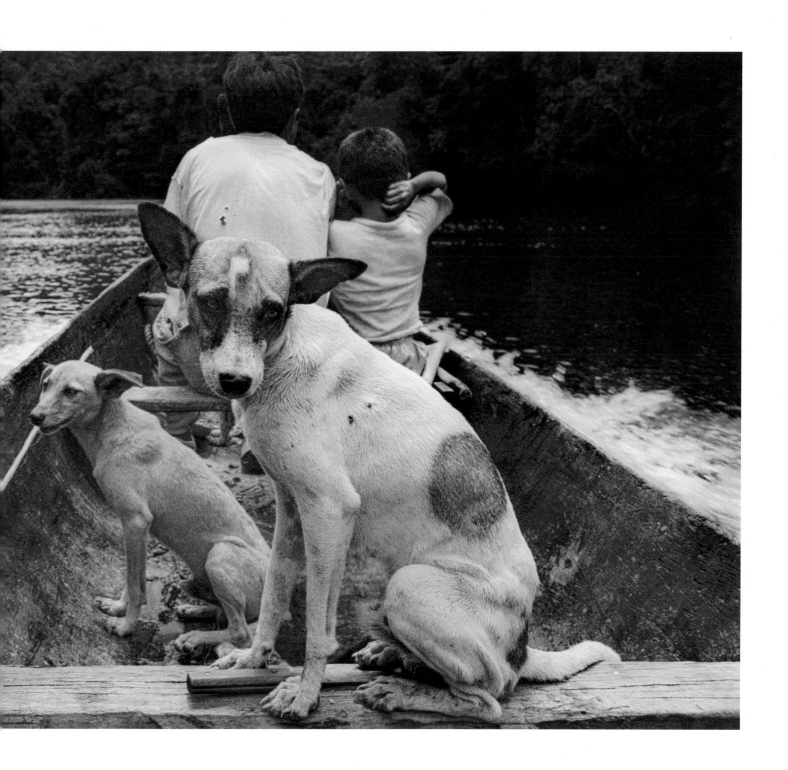

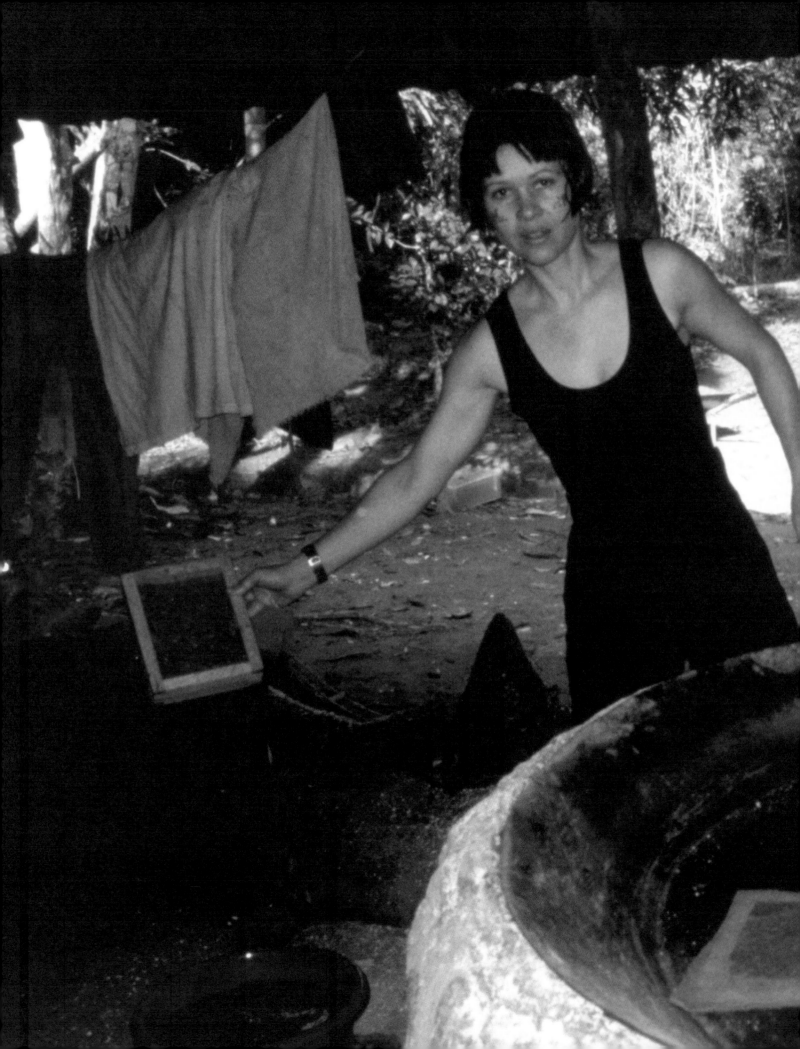

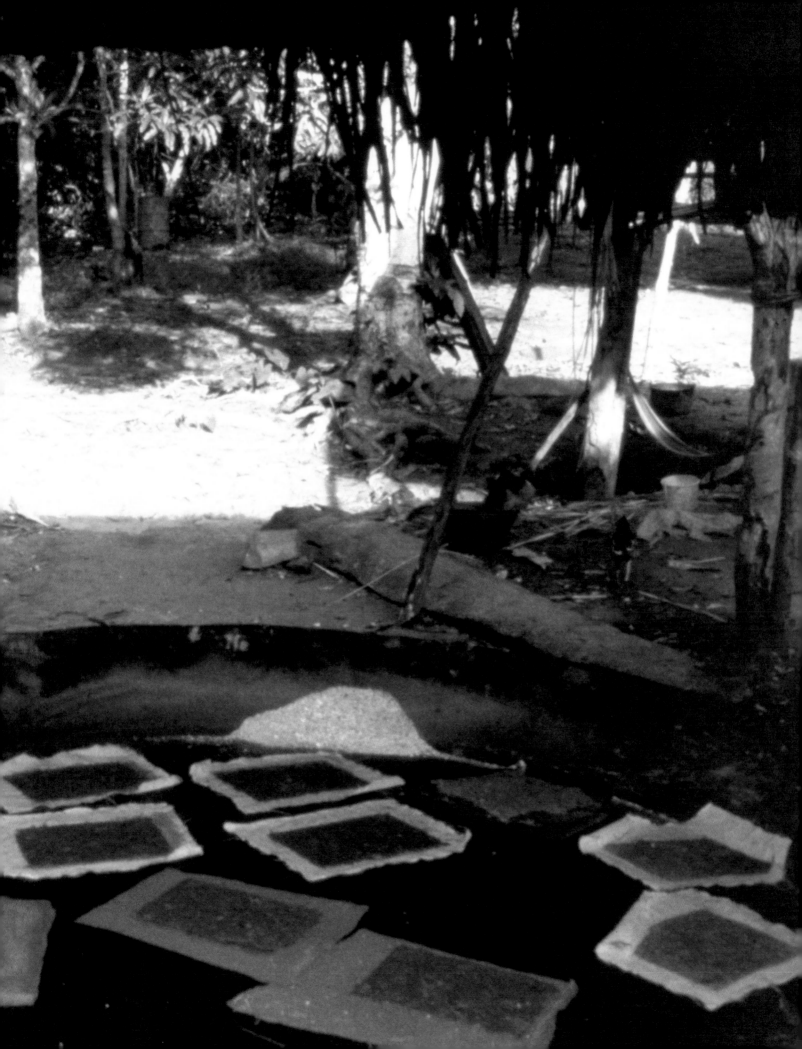

Yanomami Owë Mamotima, Sheroanawe Hakihiiwe,
and Laura Anderson Barbata
Shapono, March 1992–December 2001
water-based inks on shiki and abaca papers, ed. of 50
12⅛ × 8⅞ in. / 30.8 × 22.5 cm (with 6 interior pages)

pp. 54-55: *Memory is a Porous Archive*, 1994–2005/2023 (detail)
120 35mm slides from the Amazon, Trinidad and Tobago, Cuba,
Boreal Canada, New York, and Mexico, vitrine, unique

SHAPONO

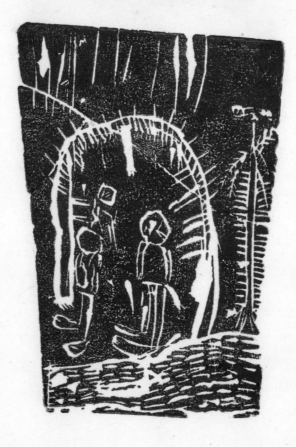

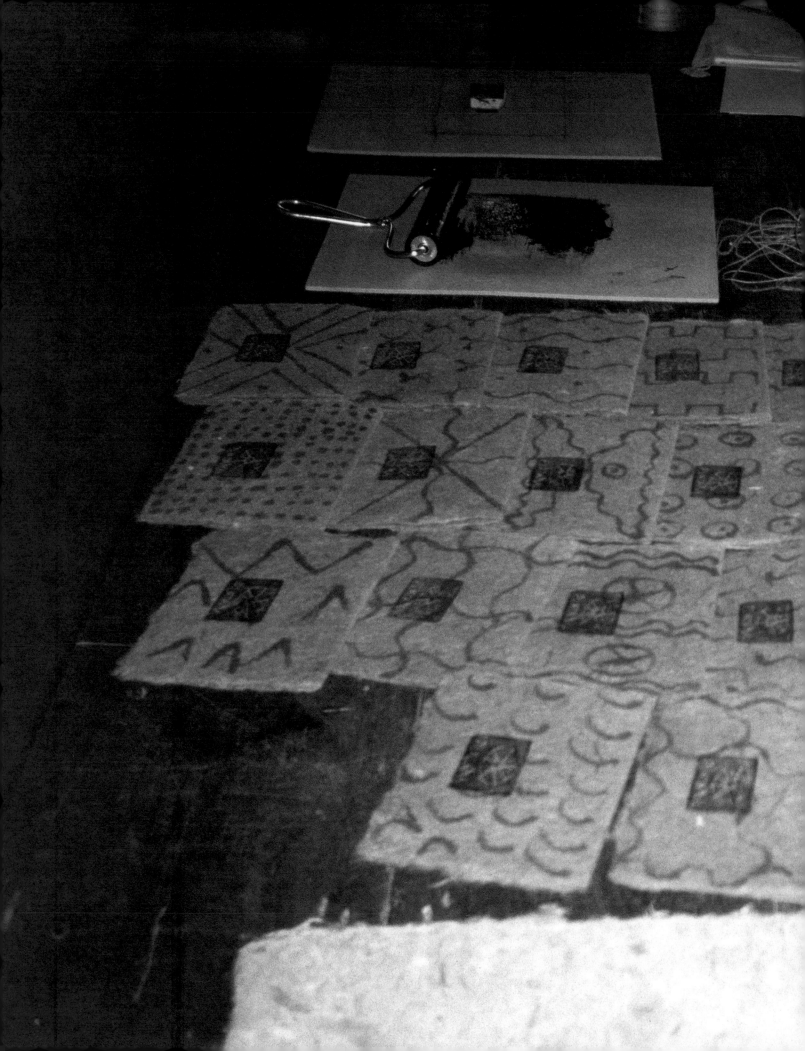

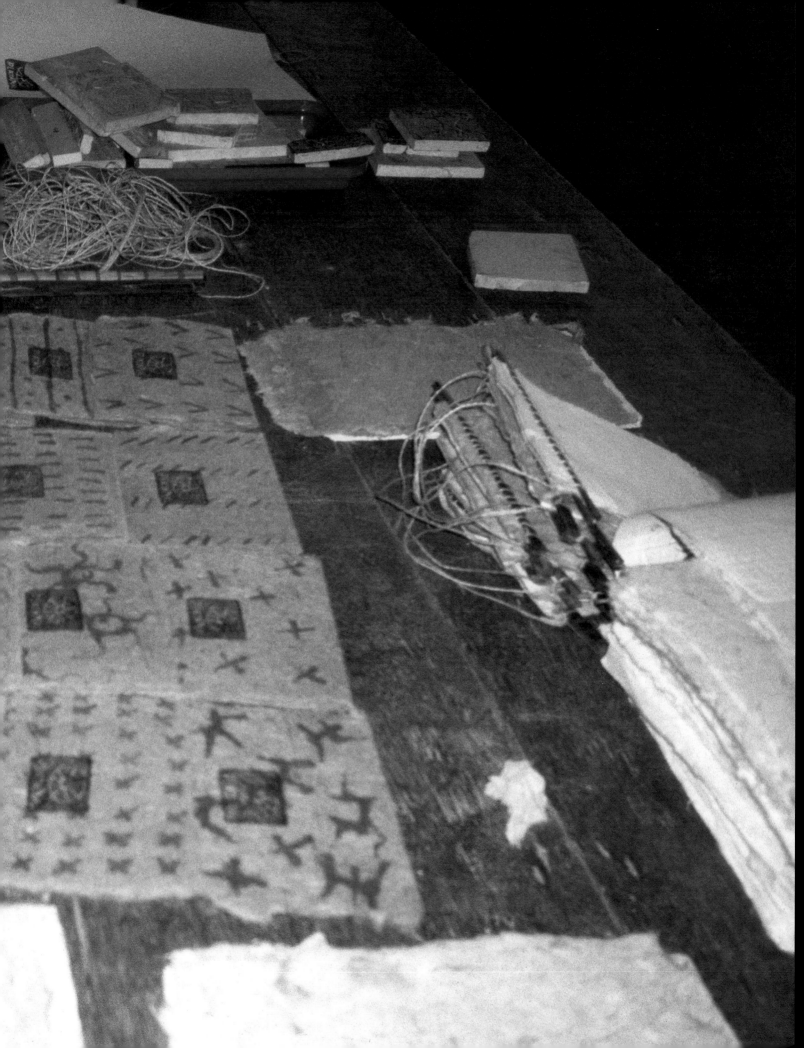

Ni todos los que son están, ni todos los que están son. El arbol de la vida según:
http://www.sil.org/ethnologue/countries/Mexi.html, 2001
double-sided lithography on gampi paper, handmade cast abaca paper
with graphite rubbing and map pins, variation from a series of 12
32 × 23 in. / 81.3 × 58.4 cm

Archive X, 1998/2023
handmade abaca paper bundles with inclusions from the New Testament
in Spanish, Ye´Kuana, Yanomami, Ashuar, Maya, and Quechua languages
on bamboo structure, unique
installation dimensions variable

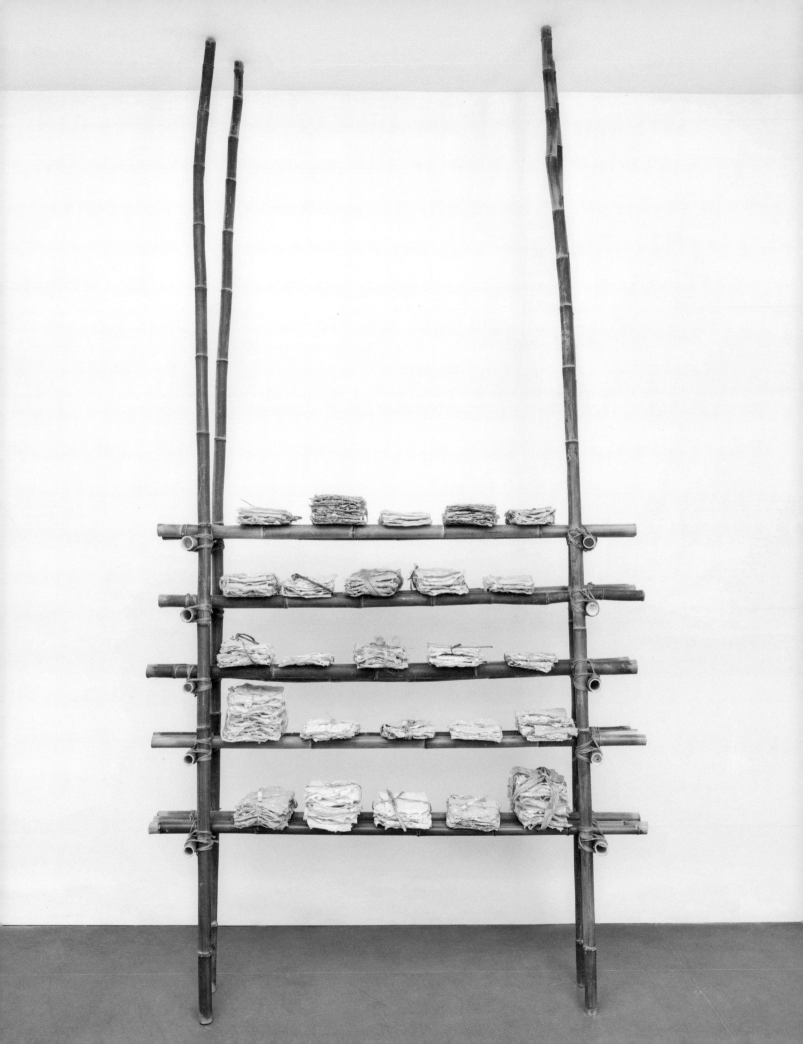

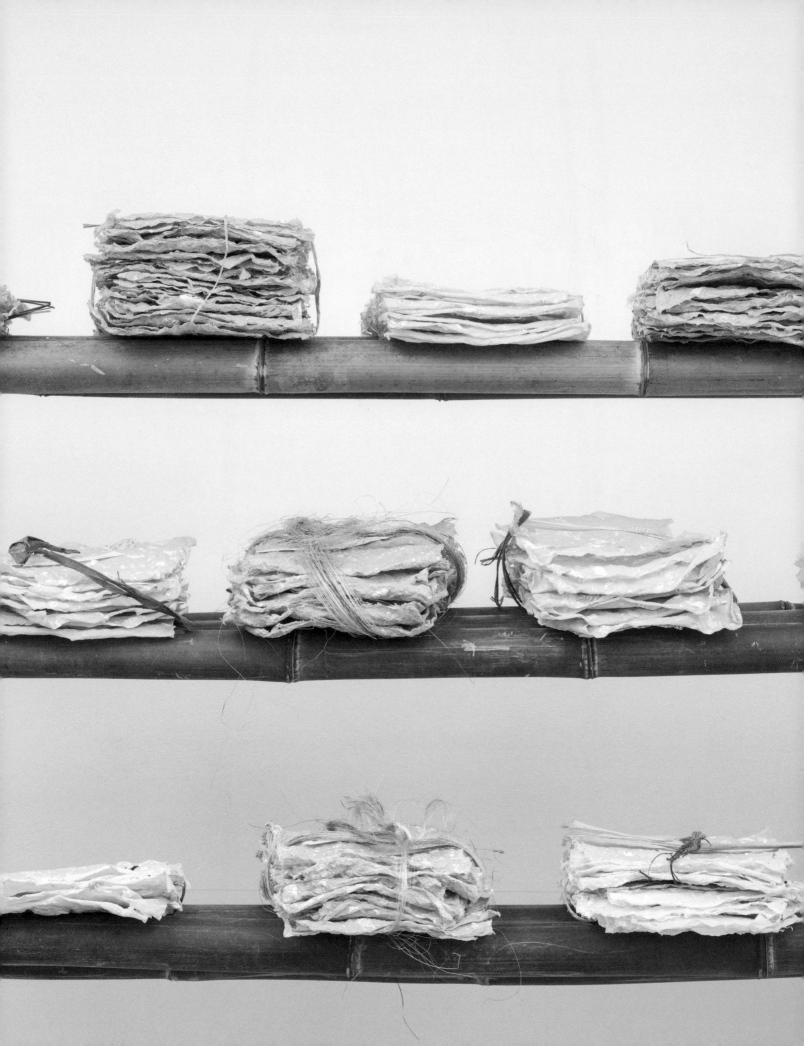

61

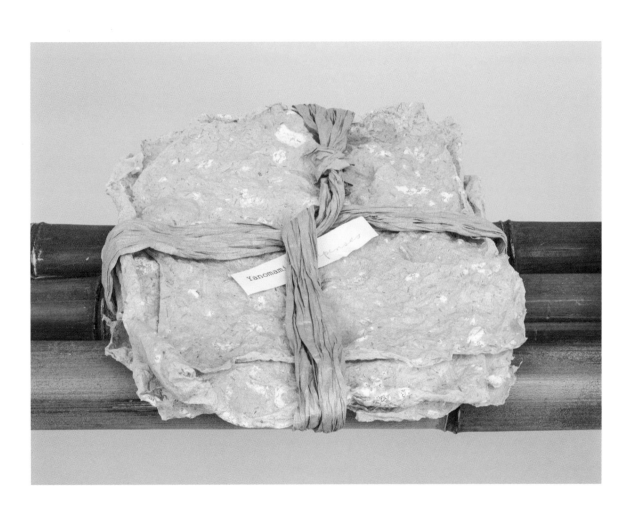

Lectura del nuevo evangelio, 1996
drawing, graphite, and wax on handmade abaca paper with inclusions
from the New Testament
polyptych, overall 38 × 30⅝ in. / 96.5 × 77.8 cm

Autorretrato (Viernes en Tamaulipas), 2012
handmade paper collages, layered
26⅛ × 19¾ in. / 66.4 × 50.2 cm

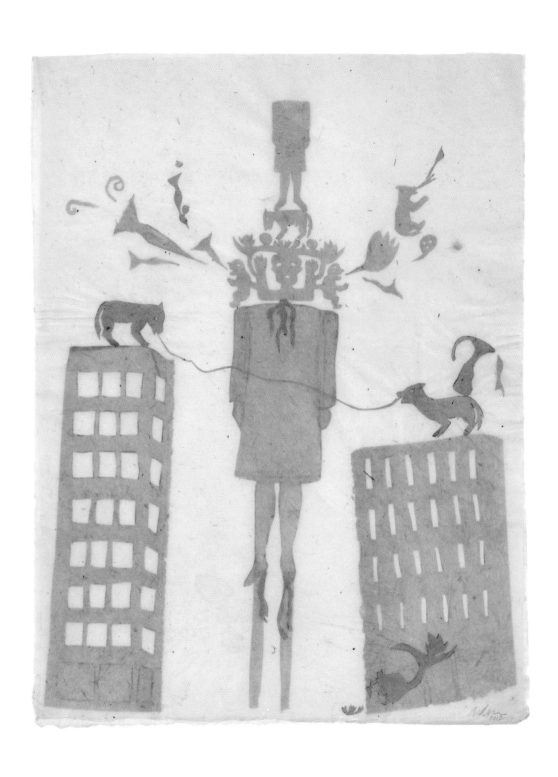

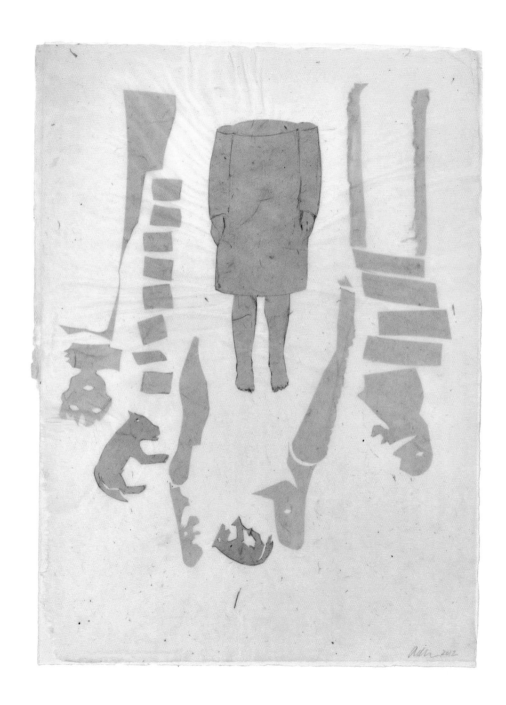

Entre los escombros (Autorretrato), 2012
handmade paper collages, layered
20 × 14¾ in. / 50.8 × 37.4 cm

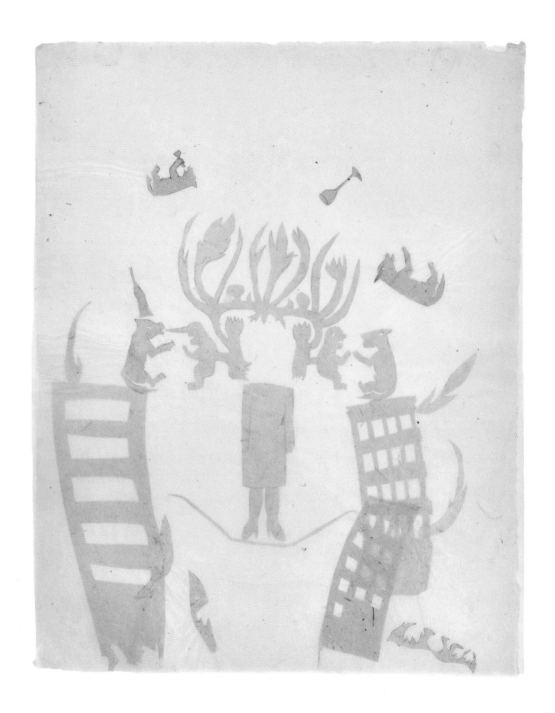

Autorretrato con mezcal, 2012
handmade paper collages, layered
24¾ × 19⅞ in. / 62.9 × 50.5 cm

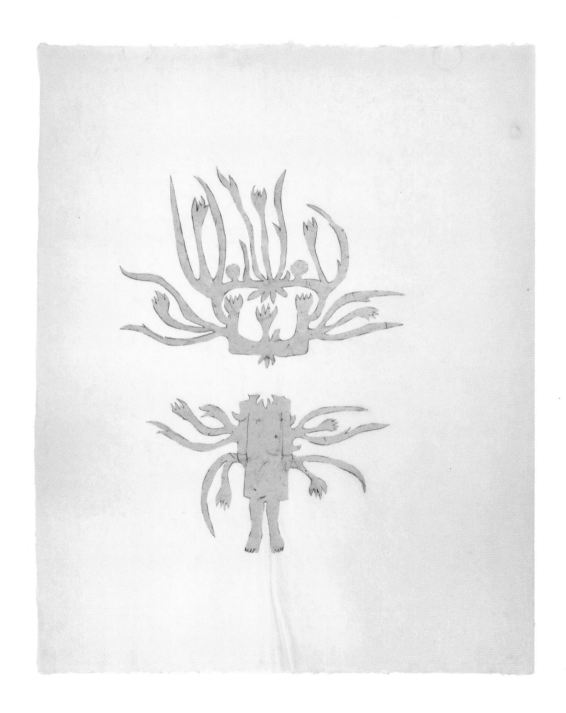

Autorretrato metafísico, 2012
handmade paper collage
24½ × 19¾ in. / 62.2 × 50.2 cm

69

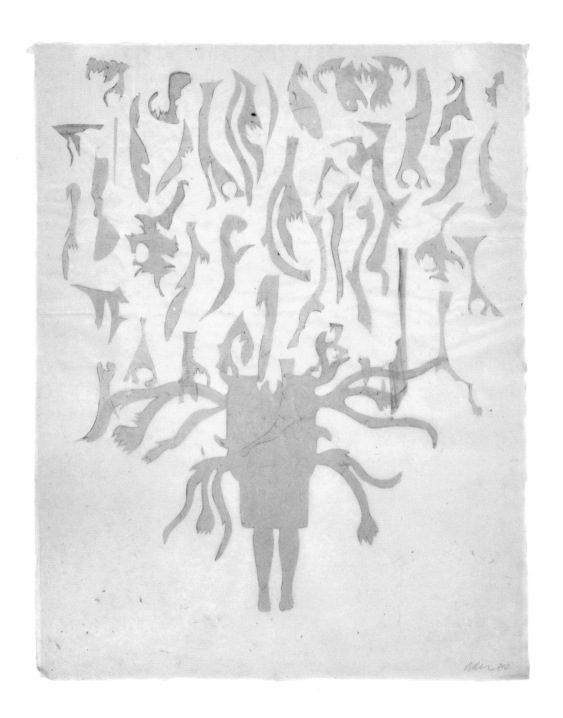

Autorretrato en deconstrucción, 2012
handmade paper collages, layered
24⅝ × 19¾ in. / 62.5 × 50.2 cm

Autorretrato urbano, 2012
handmade paper collages, layered
26 × 19⅞ in. / 66 × 50.5 cm

pp. 72–73: *Autorretrato (Primera Parte)*, 1996/2023
honey wax figure on rattan bridge with ropes and mirrors, unique
figure: 7⅞ × 3½ x 2¾ in. / 20 × 8.9 × 7 cm
installation dimensions variable
Installed in the artist's New York studio (1996).
Courtesy Museo Universitario Arte Contemporáneo, DGAV-UNAM
Photo: Stefan Hagen

pp. 74–75: *El viaje (Autorretrato)*, 1996/2023
carved wood canoe, honey wax figures, corn, and plexiglass atop
fresh marigold petals, dried marigold petals, and paper petals, unique
canoe: 12 × 56 × 7¾ in. / 30.5 × 142.2 × 19.7 cm
installation dimensions variable

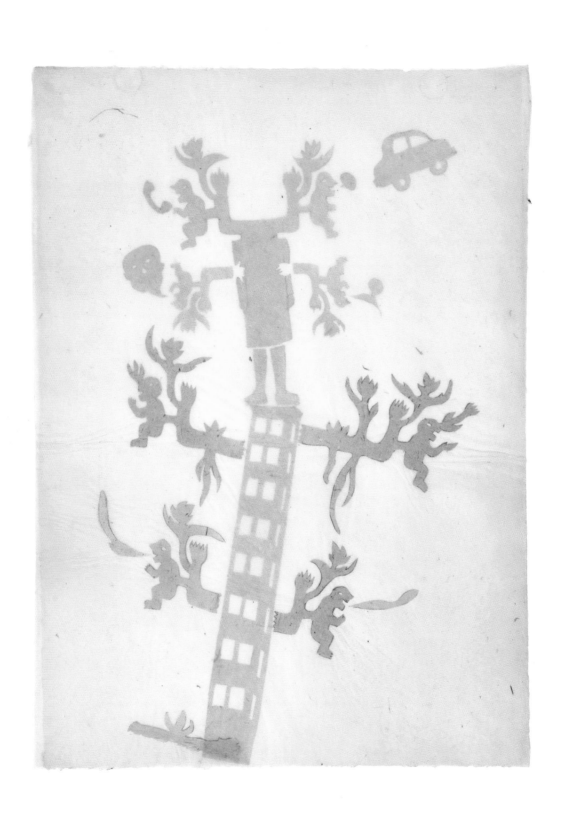

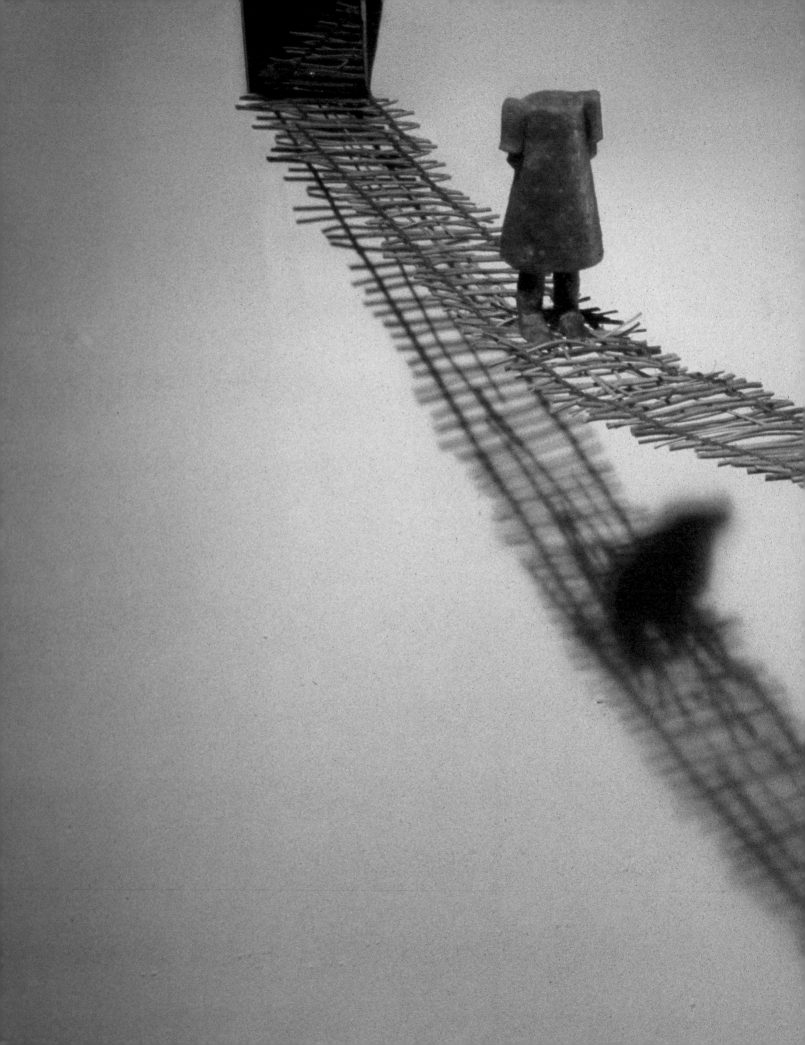

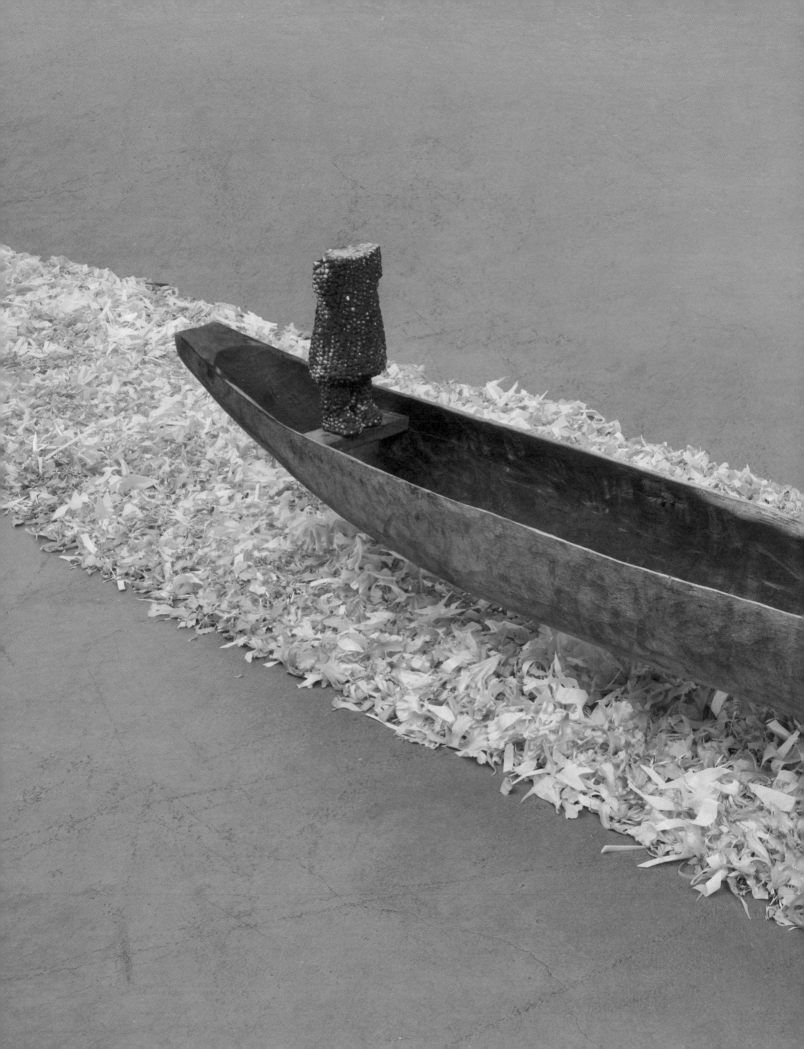

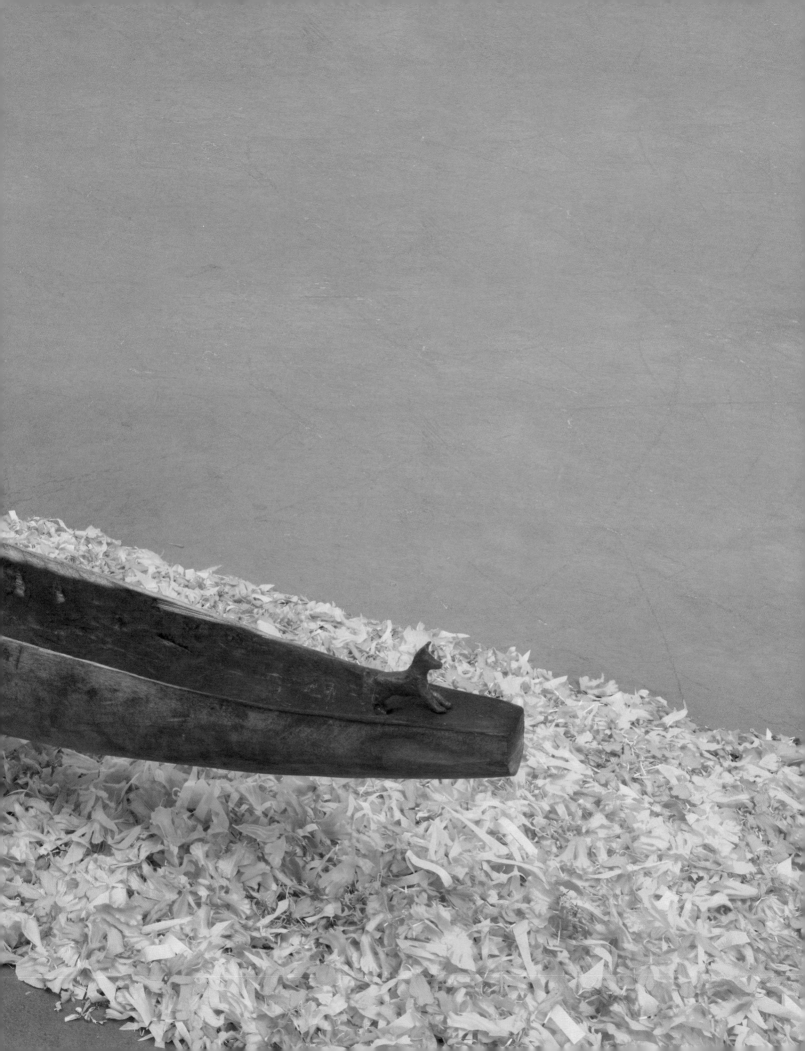

Self-Portrait (With Cochinilla), 2023
silk jacquard hand dyed with cochineal, turmeric, iron,
indigo, and rose petals with wax, charcoal, and graphite
73½ × 39½ in. / 186.7 × 100.3 cm

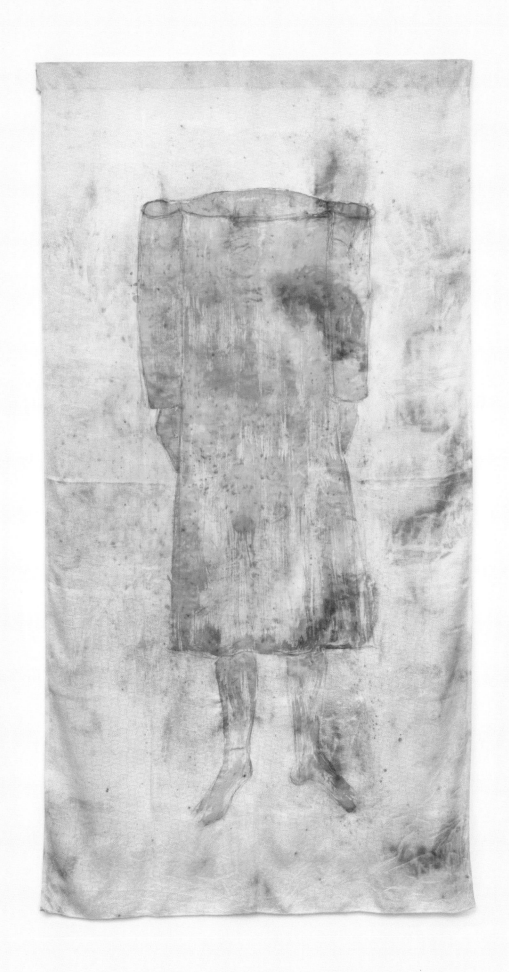

Self-Portrait (With Honey Wax), 2023
silk jacquard hand dyed with cochineal, turmeric,
and hibiscus with wax, conté stick, and graphite
74 × 39½ in. / 188 × 100.3 cm

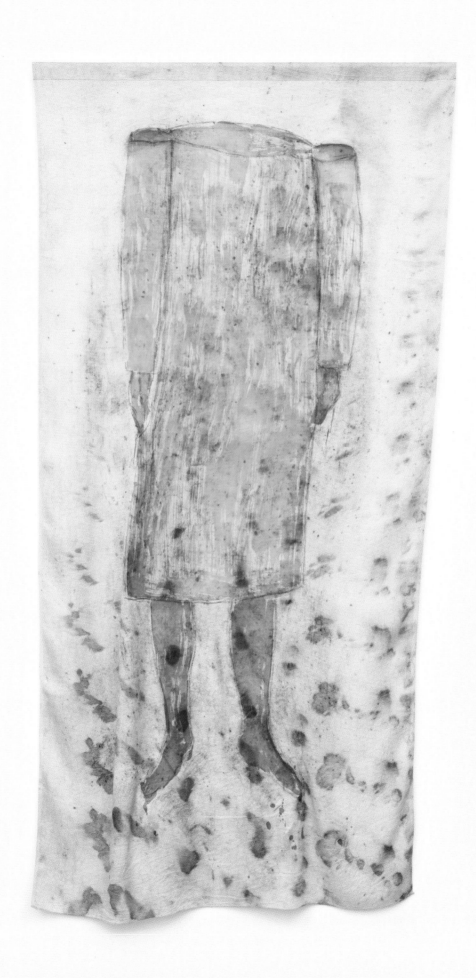

Self-Portrait (Process of Becoming), 2023
silk jacquard hand dyed with marigolds, onion skins,
tea, and rust, with gall ink, conté stick, and charcoal
73 × 39½ in. / 185.4 × 100.3

Tlacaxipehualiztli, 1998
found portraits with orchid leaf insertions
50 × 51 in. / 127 × 129.5 cm

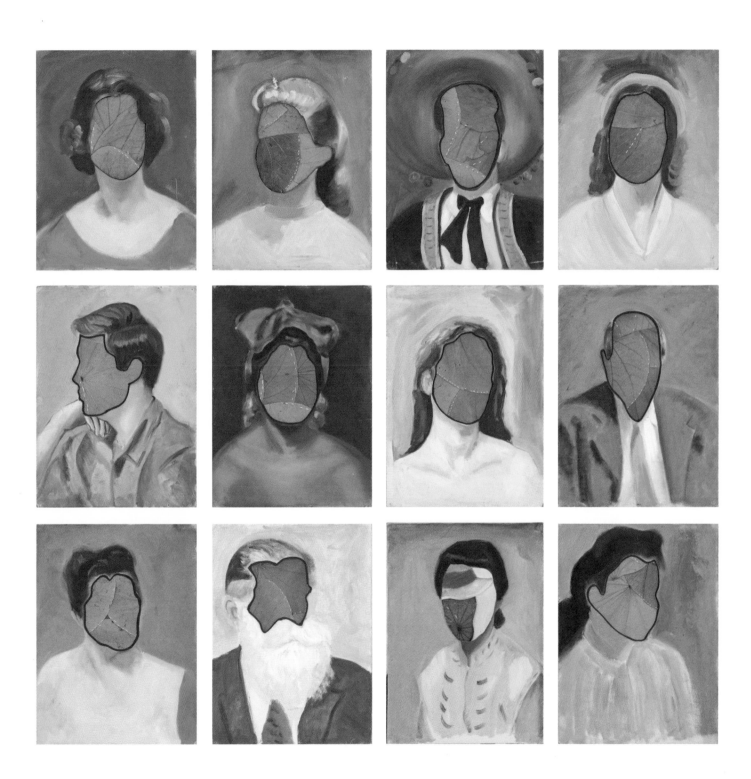

Caras vemos (corazones no sabemos), 1997
polychromed wood, incised pearl, and honey wax, unique
¾ × 1 × 1¾ in. / 1.9 × 2.5 × 4.4 cm

pp. 86–87: *Yo no soy digno de que vengas a mí, pero una palabra tuya
bastará para sanar mi alma*, 1996
cast gesso, cotton thread with incised pearls, unique
ear: 4¾ × 3⅛ in. / 12.1 × 7.9 cm
installation dimensions variable

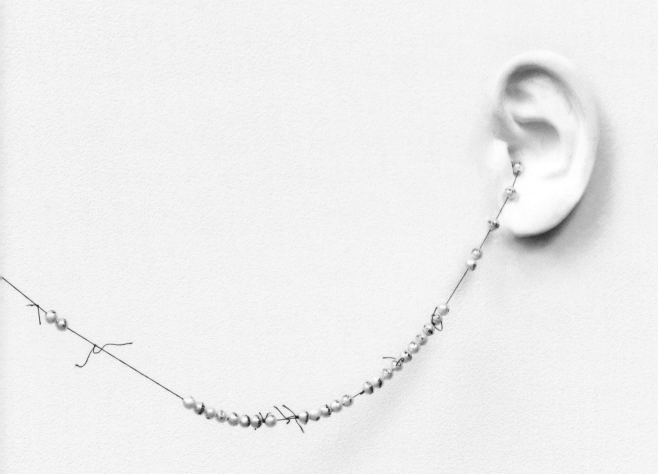

El libro de los magos del popol vuh, 1996
honey wax, pearls, and corn on wood base, unique
7 × 9 × 5¼ in. / 17.8 × 22.9 × 13.3 cm

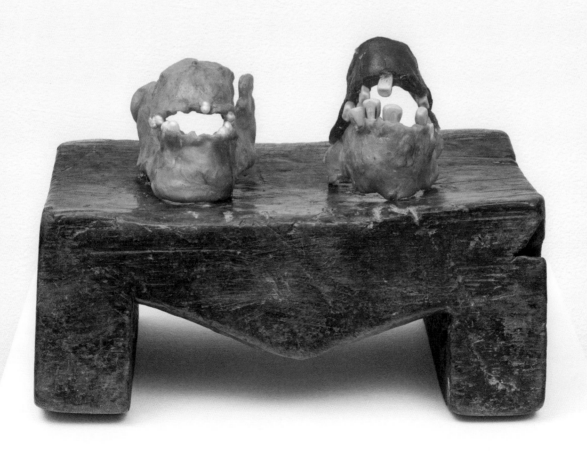

El miedo no anda en burro (autorretrato), 1998/2023
honey wax, mirror, sticks, and stones, unique
15½ × 7⅞ × 6 in. / 39.4 × 20 × 15.2 cm

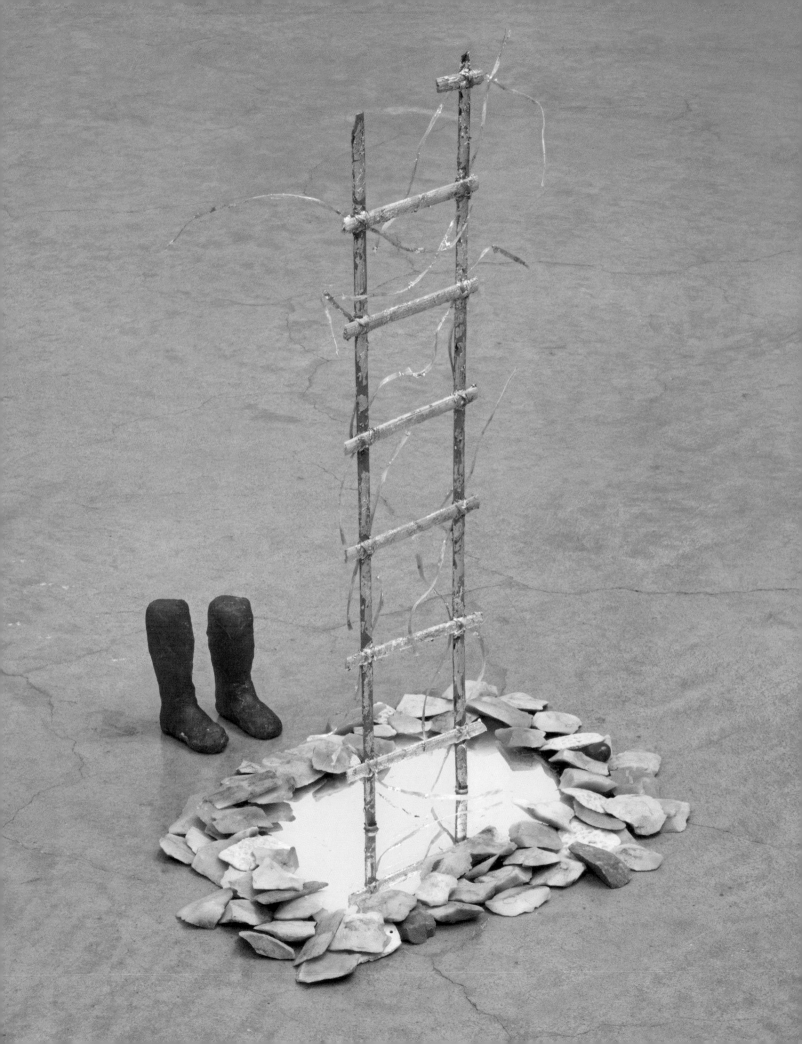

Consuelo, 2006
polychromed Linden wood, unique
58 × 30 × 20½ in. / 147.3 × 76.2 × 52.1 cm

pp. 94–95: *Consuelo*, 2002
single-channel video, sound, ed. of 3 + 2 AP
8 minutes, looped
Installation view, Ex Teresa Arte Actual,
Mexico City, Mexico (2002).
Photo: Javier Hinojosa

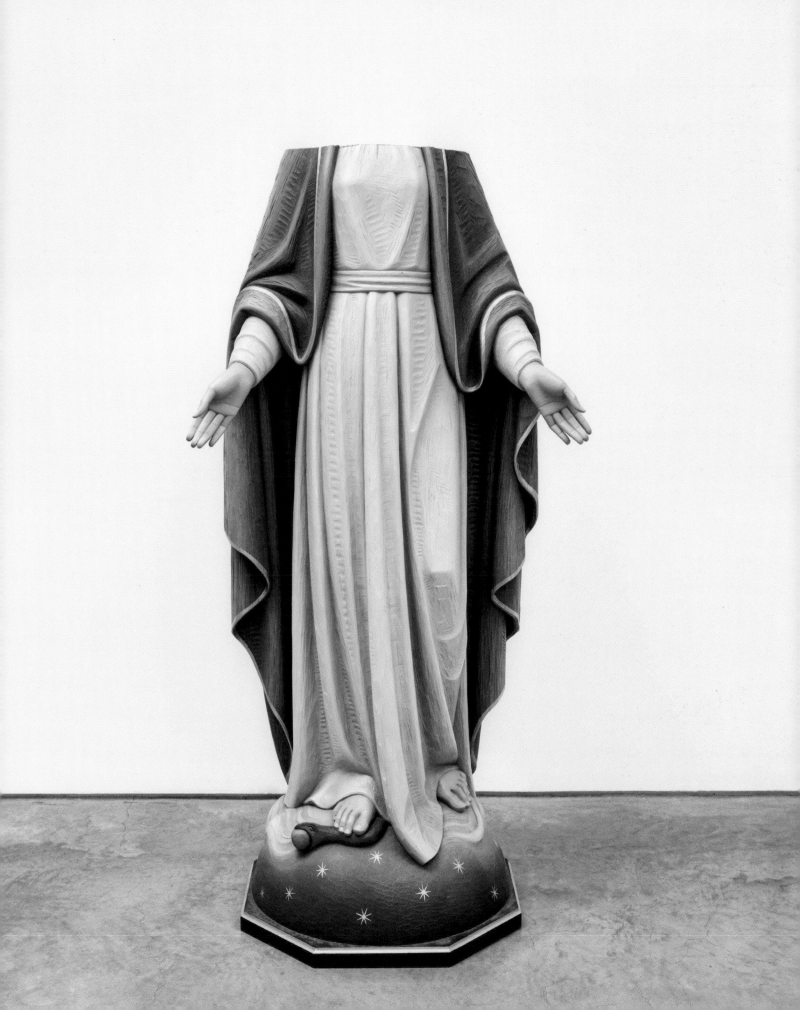

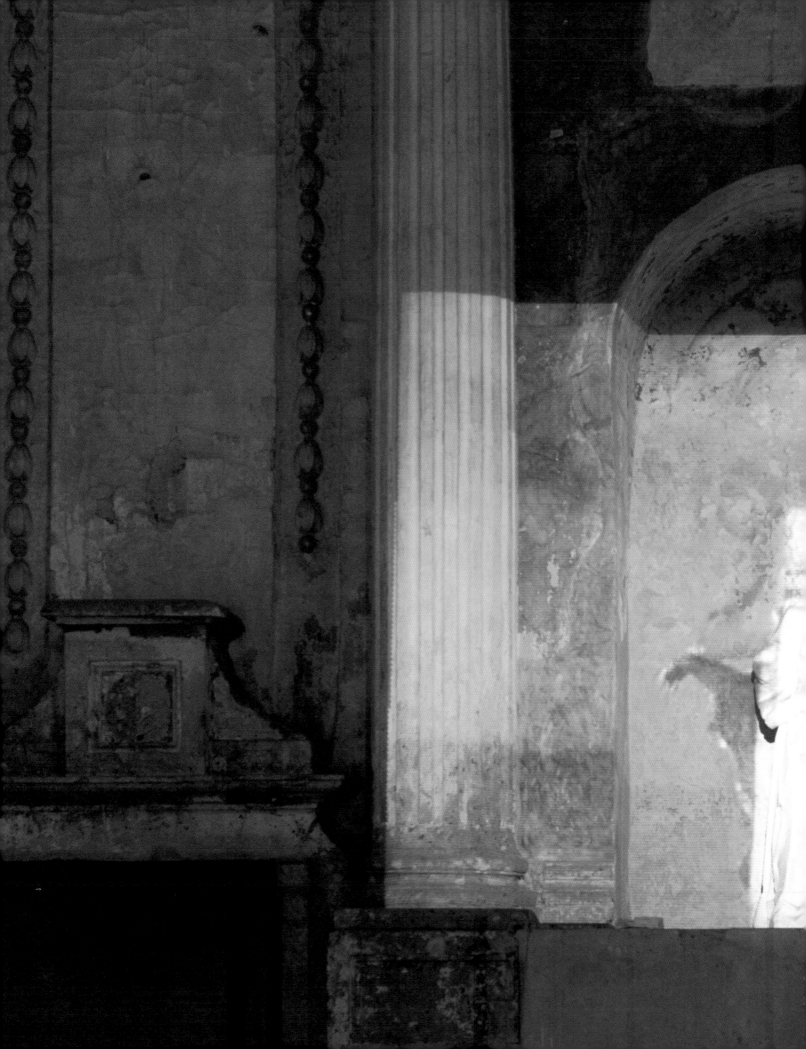

Consuelo, 2004
24-layer Lenticular print mounted on aluminum,
ed. of 5 + 2 AP
25½ × 39 in. / 64.8 × 99.1 cm

Gloria, 2006
24-layer Lenticular print mounted on aluminum,
ed. of 3 + 2 AP
62¾ × 42⅛ in. / 159.4 × 107 cm

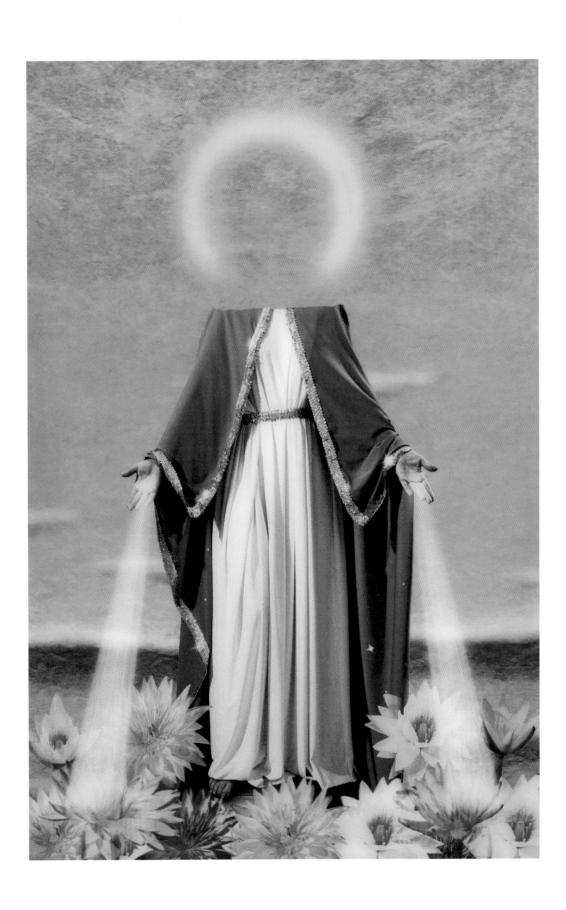

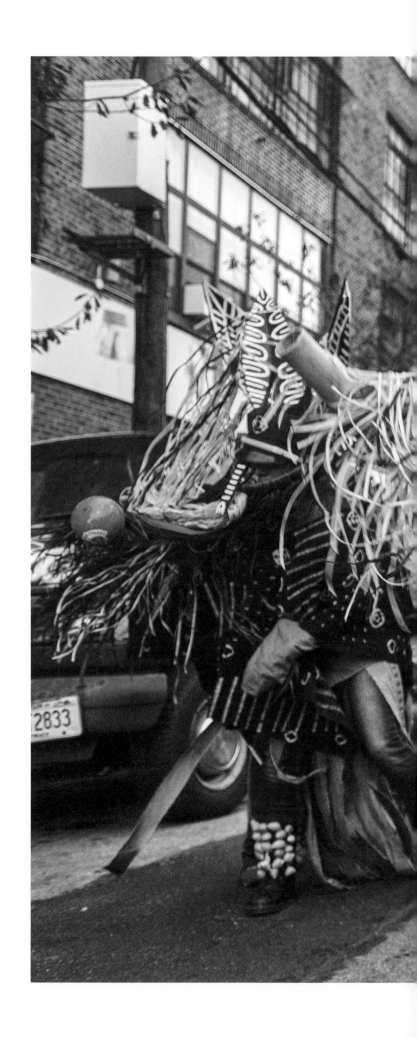

Intervention: Indigo, 2015/2020
Presented in 2015 in Brooklyn, New York.
Performed in collaboration with the Brooklyn Jumbies,
Chris Walker, and Jarana Beat.
Photo: Rene Cervantes

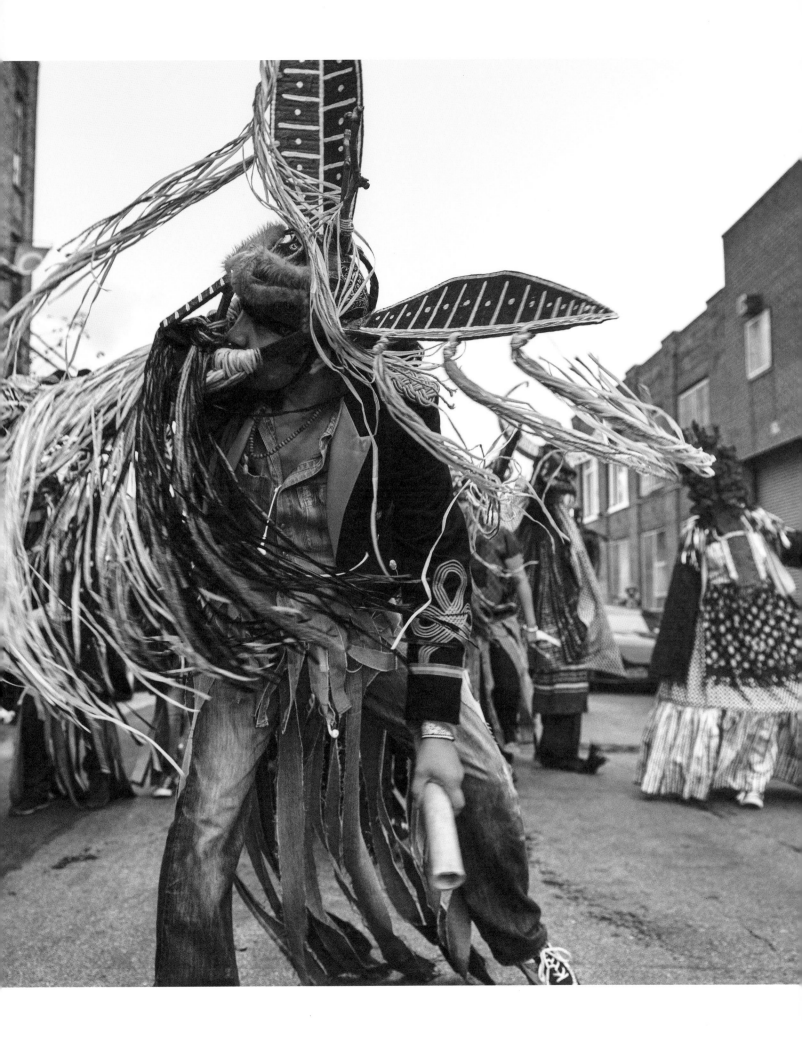

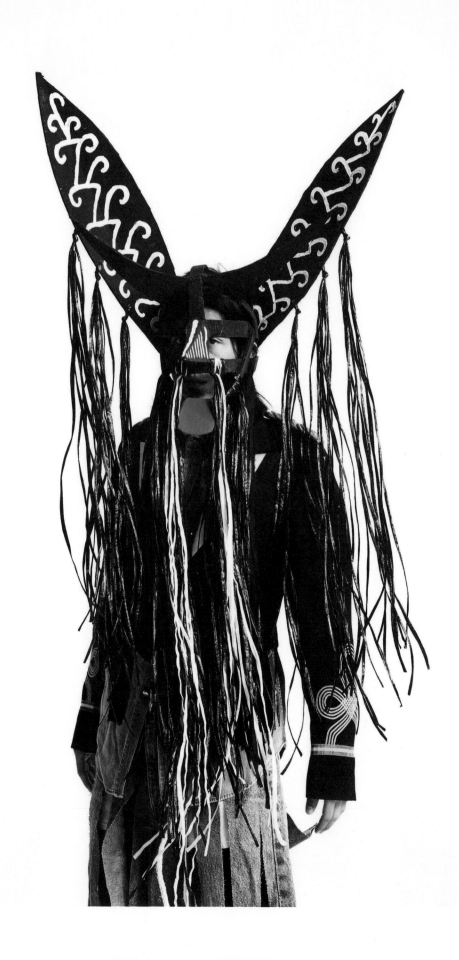

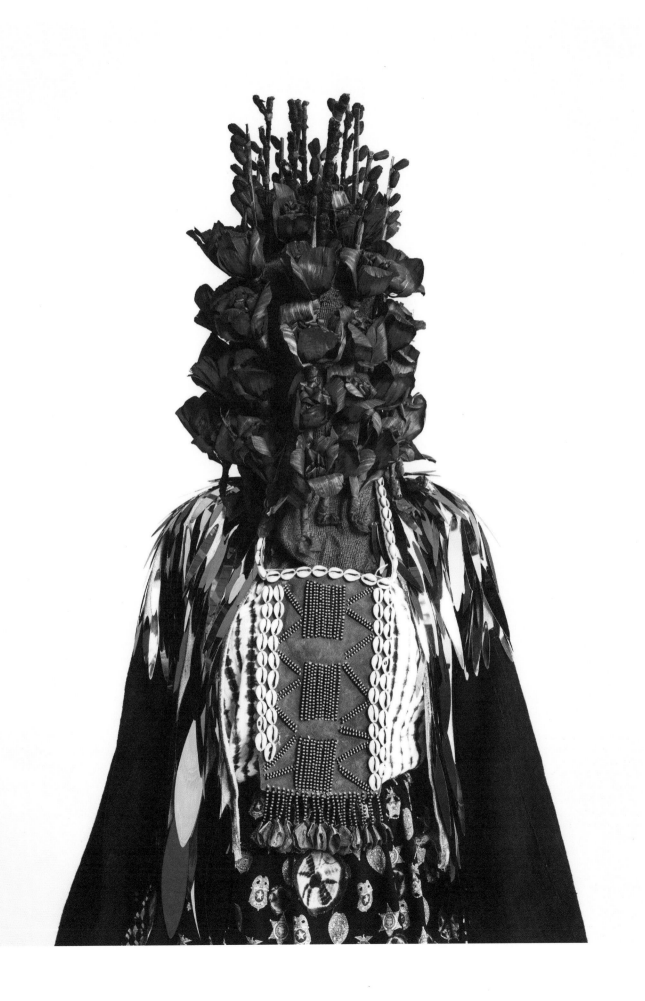

p. 102: *Diablo 1*, 2015 (detail)
military jacket, denim, assorted synthetic fibers, fabric-mâché on cardboard, paint, and sisal, unique
93 × 36 × 20 in. / 236 × 91 × 50 cm

p. 103: *Indigo Queen*, 2015 (detail)
handmade indigo-dyed cotton from Burkina Faso, assorted cotton textiles, chest piece from Burkina Faso, sequins, raw silk, dyed corn leaf flowers, paper, and cotton thread, unique
78 × 38 × 38 in. / 198 × 96 × 96 cm

opposite: *Rolling Calf*, 2015
hand-dyed indigo cotton brocade, handmade indigo-dyed cotton from Burkina Faso, assorted cotton textiles, machine embroidery from Oaxaca, natural fiber basket from the Amazon, fabric-mâché, buttons, leather, and decorated sneakers, unique
90 × 23 × 26 in. / 228 × 58 × 66 cm

p. 106: *Indigo King*, 2015
handmade indigo-dyed cotton textiles from Burkina Faso, vintage wedding veil with shells and mirror appliqués on cotton from India, denim, and wire, unique
143 × 19 × 13 in. / 363 × 48 × 33 cm

p. 107: *Indigo Angel*, 2015
indigo-dyed cotton textiles, Maasai necklace, denim, assorted buttons, and pheasant feathers, unique
127 × 19 × 13 in. / 322 × 48 × 33 cm

pp. 108–09: *Intervention: Indigo* installed in the artist's Brooklyn studio (2016). Photos: Dora Somosi

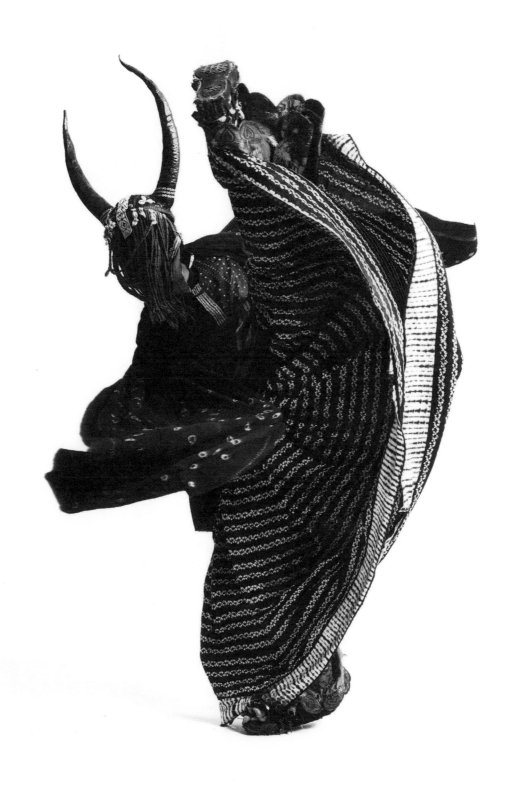

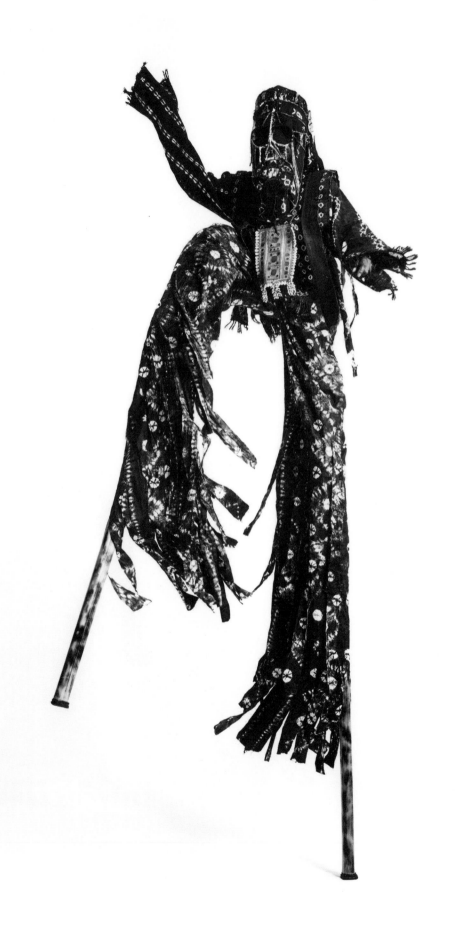

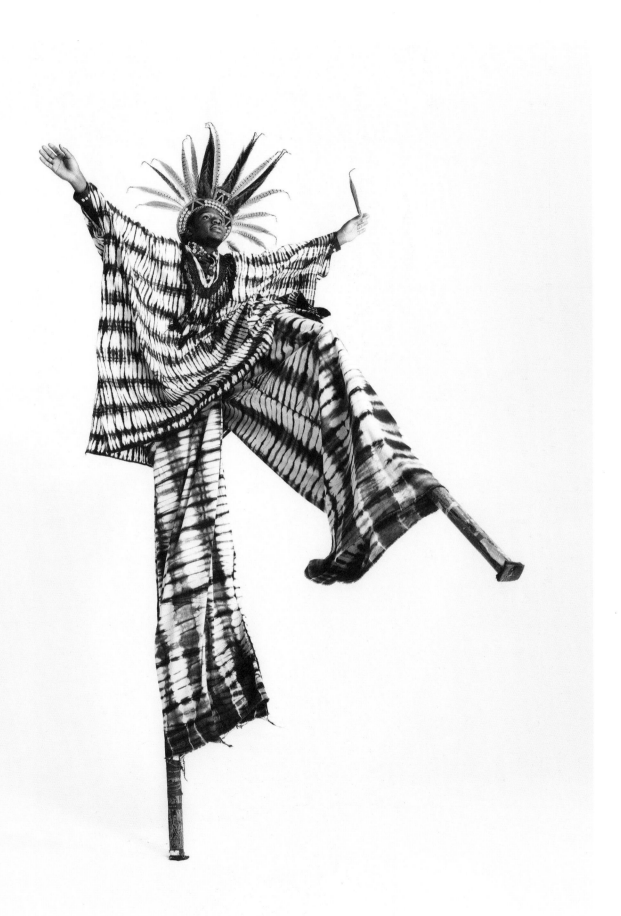

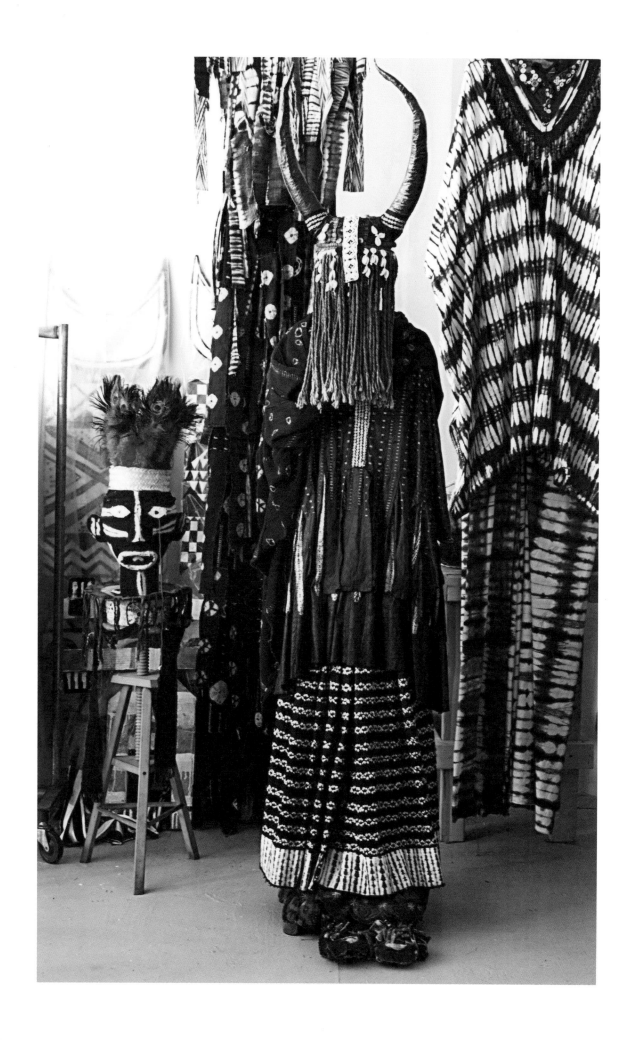

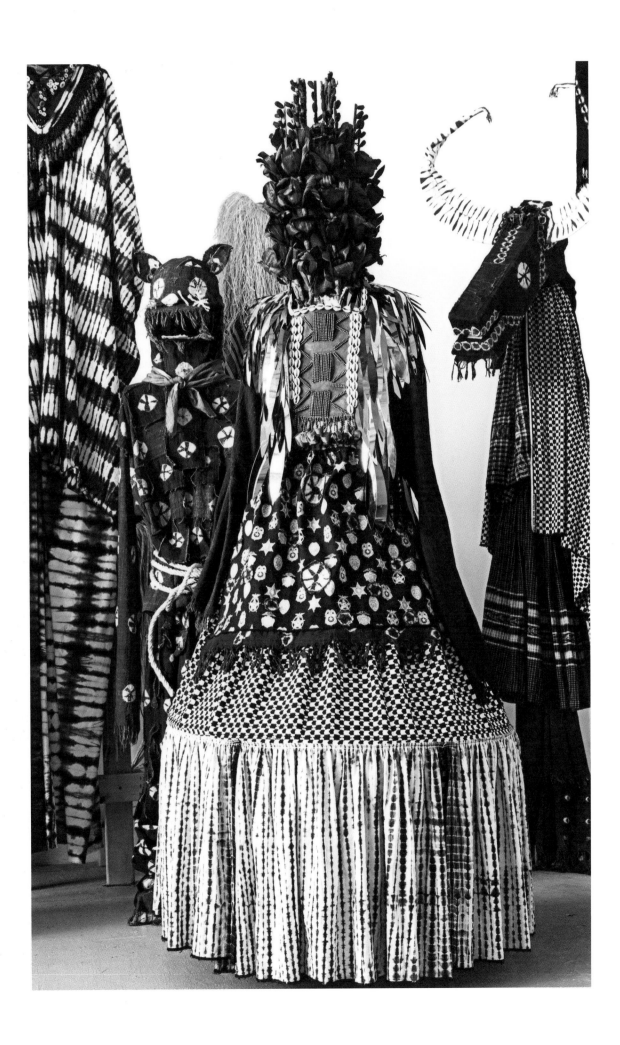

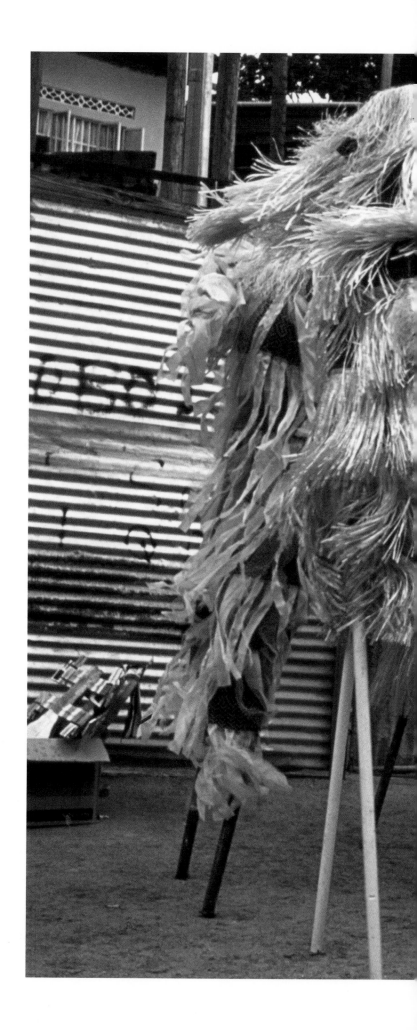

Reina Nyame in *Osebo's Drum: A West African Tale* (2005).
Practice for Junior Carnival Parade with Keylemanjahro Moko Jumbies,
Cocorite, Port of Spain, Trinidad and Tobago.
Photo: Stefan Falke

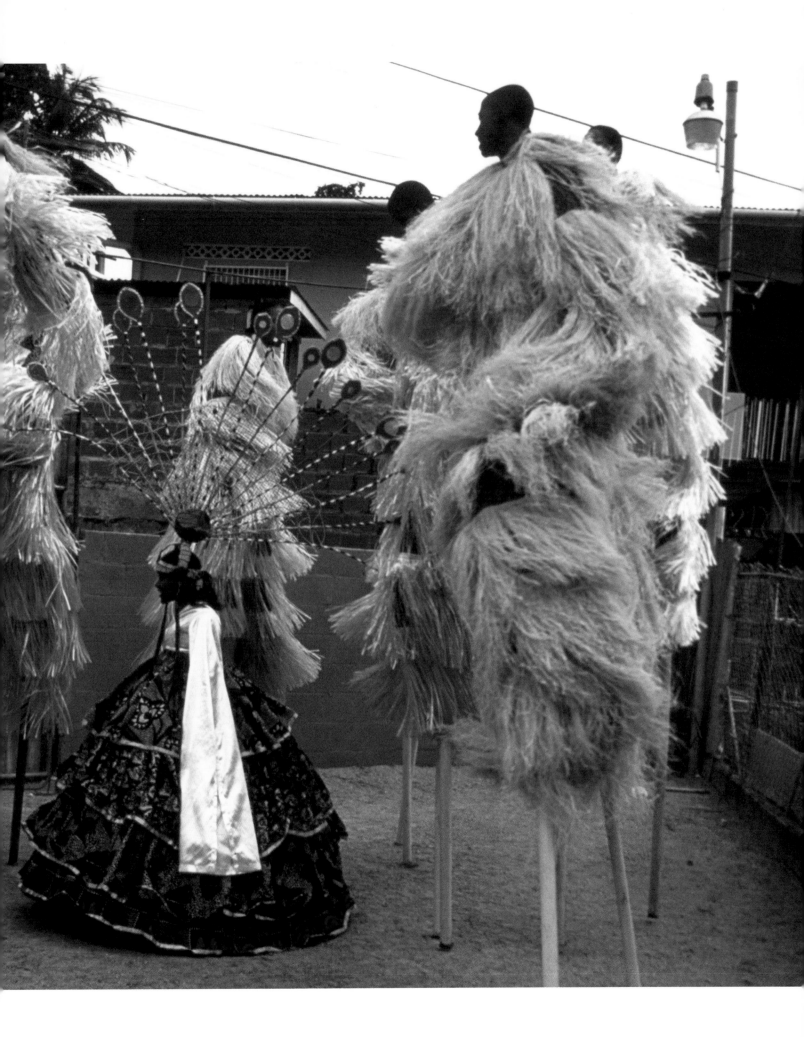

Reina Nyame, 2005–07
assorted wax print textiles from West Africa, wood, cane,
fiberglass, mesh, mirrors, papier-mâché, and painting, unique
123¼ × 82⅝ × 82⅝ in. / 313 × 210 × 210 cm

113

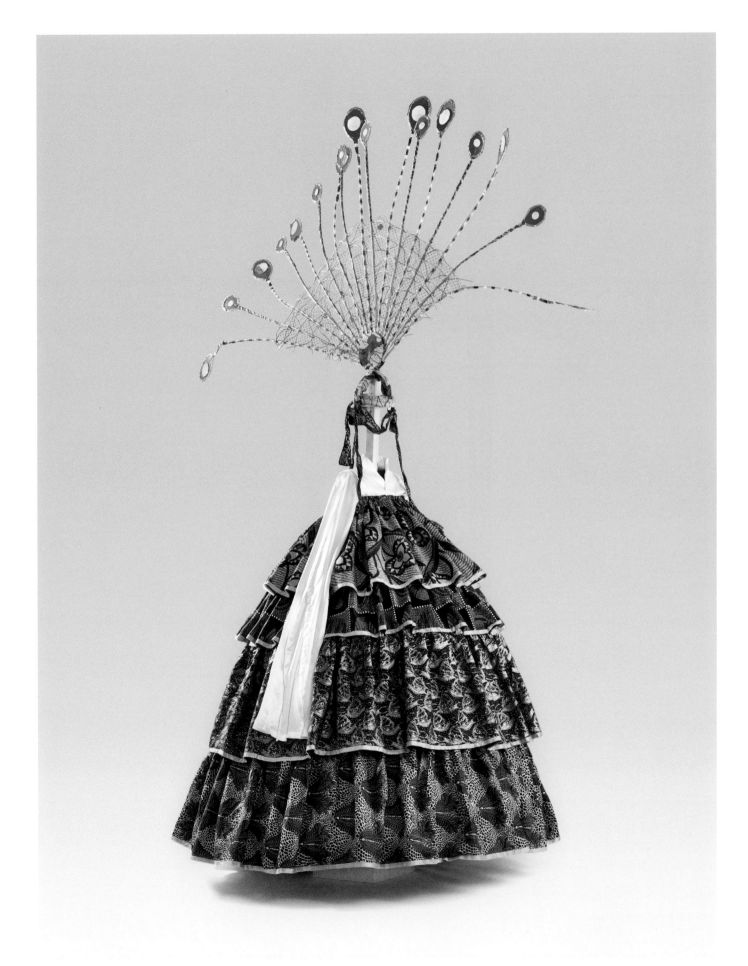

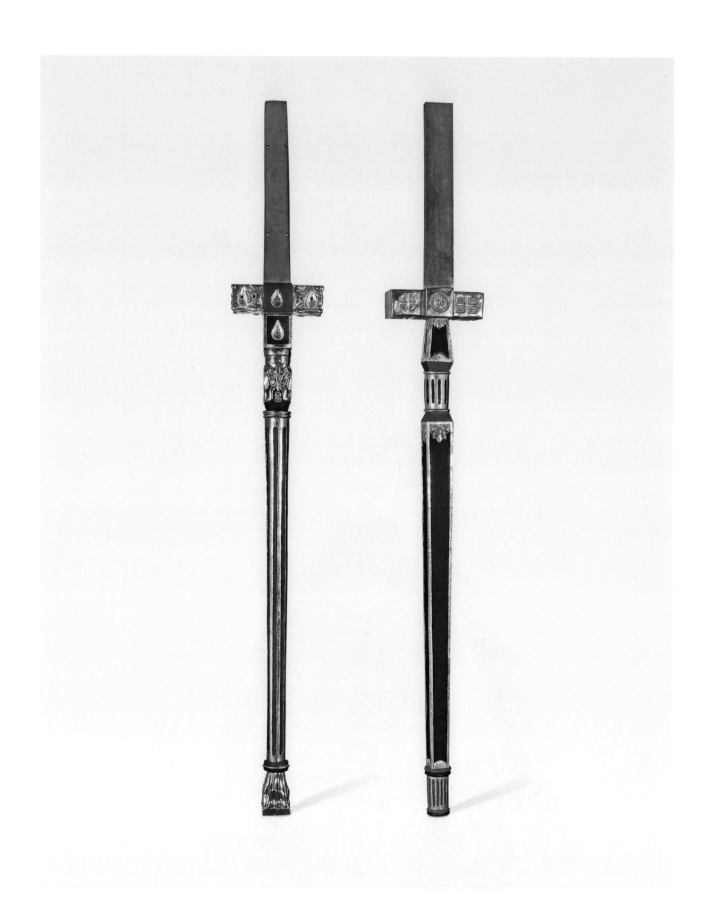

Columnas Novohispanas, 2012
carved and polychromed cedar wood with gold and silver leaf insertions, oil paint, and mirrors, made following the Novohispano retablos tradition, unique each 85¾ × 12 × 6 in. / 217.8 × 30.5 × 15.2 cm

Laura Anderson Barbata preparing for an intervention with the Brooklyn Jumbies, Teotitlán del Valle, Oaxaca (2012).
Photo: Marco Pacheco

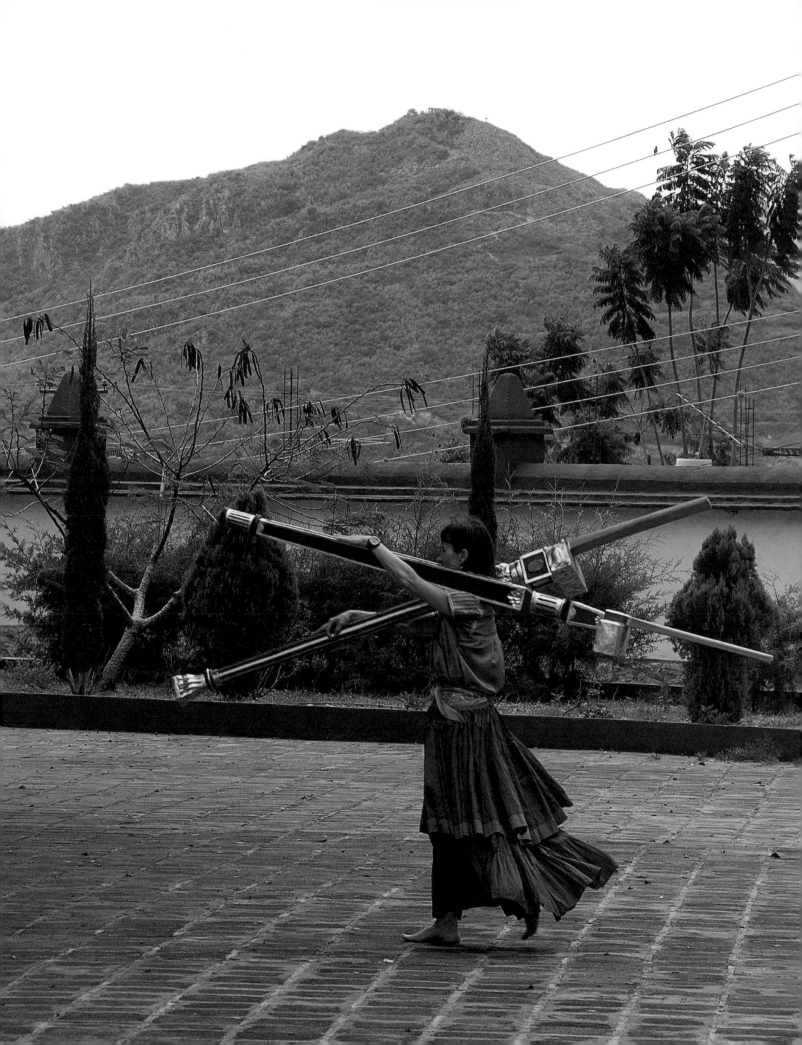

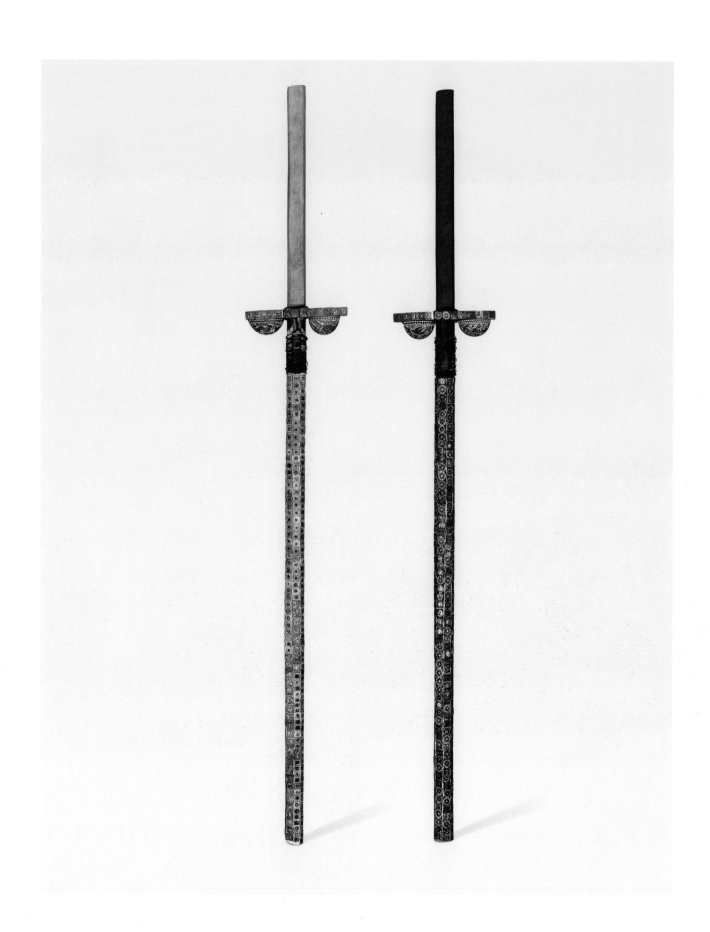

Jícaras, 2012
carved and tinted gourd mosaics on wood, made using traditional
techniques from the Afro-Mexican coast of Oaxaca, unique
each 79 × 6 × 11 in. / 200.7 × 15.2 × 27.9 cm

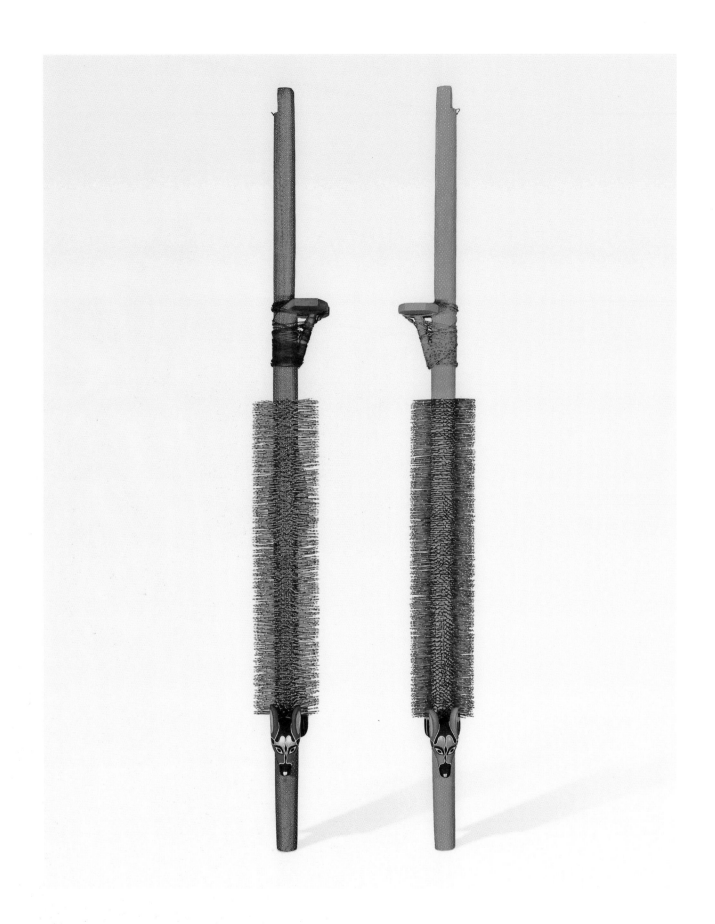

117

Puerco espín, 2012
carved and painted wood made following alebrije traditions
of San Martín Tilcajete, Oaxaca, unique
each 79½ × 8¼ × 10¾ in. / 201.9 × 21 × 27.3 cm

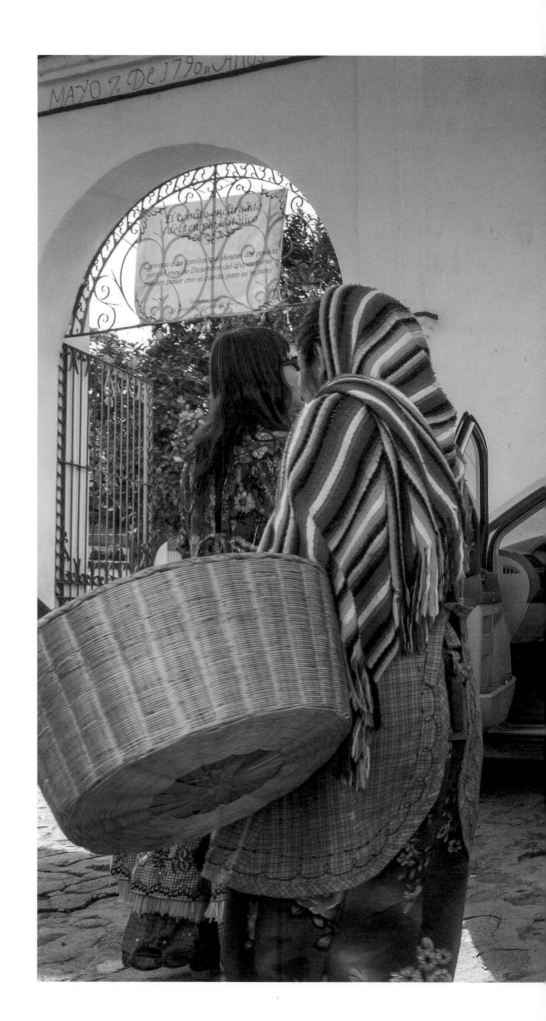

Laura Anderson Barbata preparing for
an intervention with the Brooklyn Jumbies,
Teotitlán del Valle, Oaxaca (2012).
Photo: Marco Pacheco

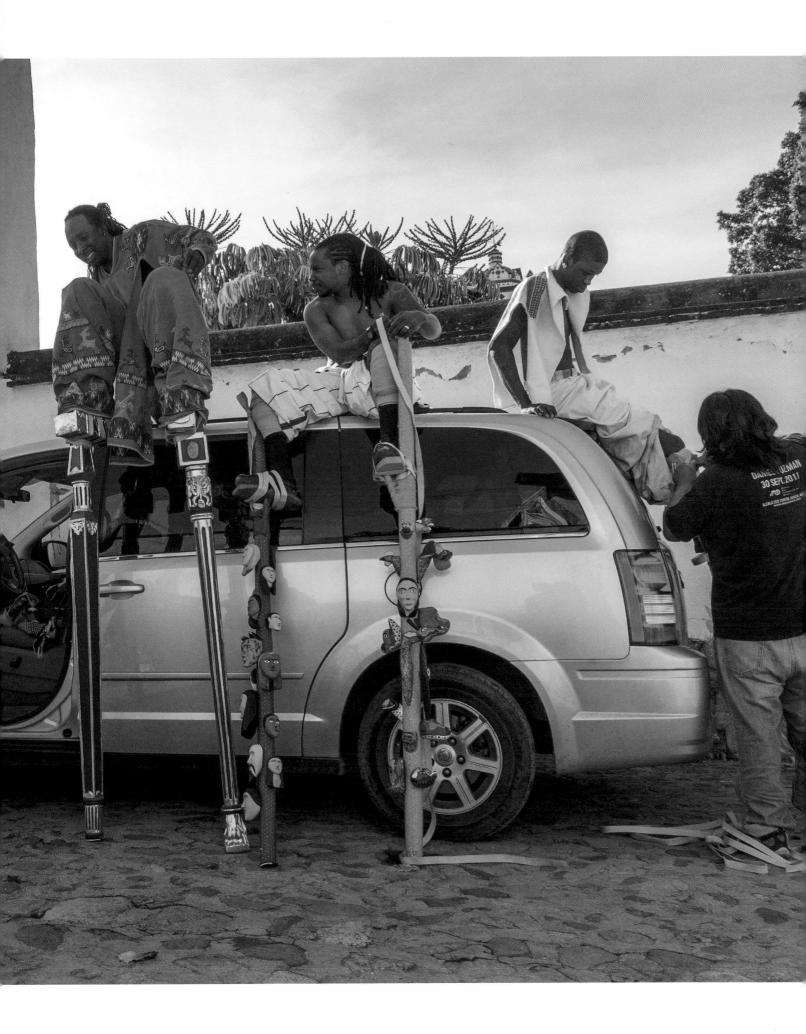

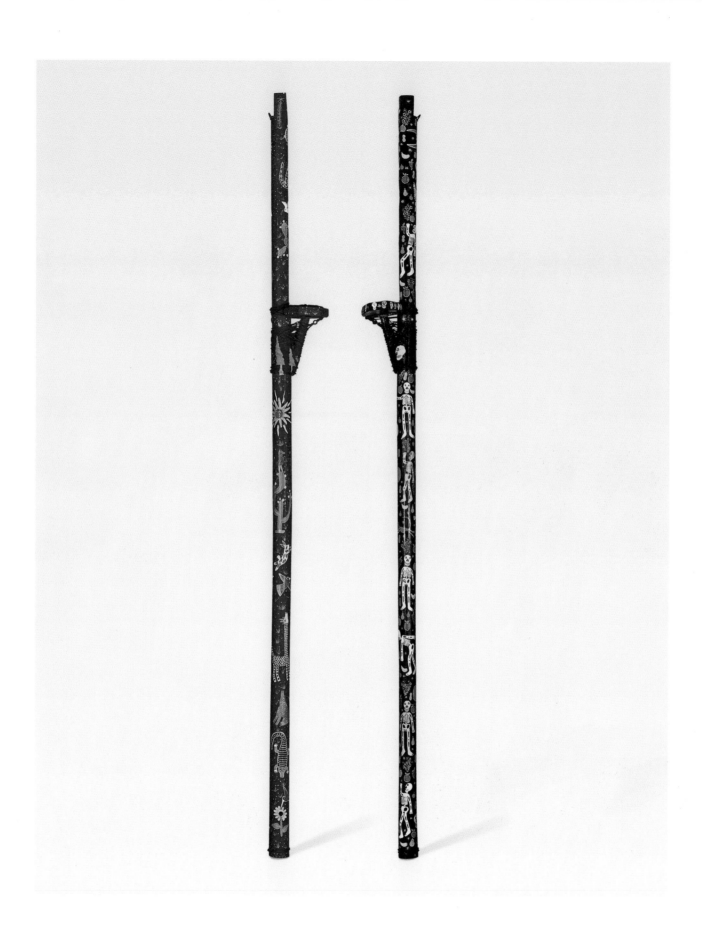

Vida y muerte, 2011–12
carved and painted wood made following alebrije traditions
of San Martín Tilcajete, Oaxaca, unique
each 73 × 6 × 11 in. / 185.4 × 15.2 × 27.9 cm

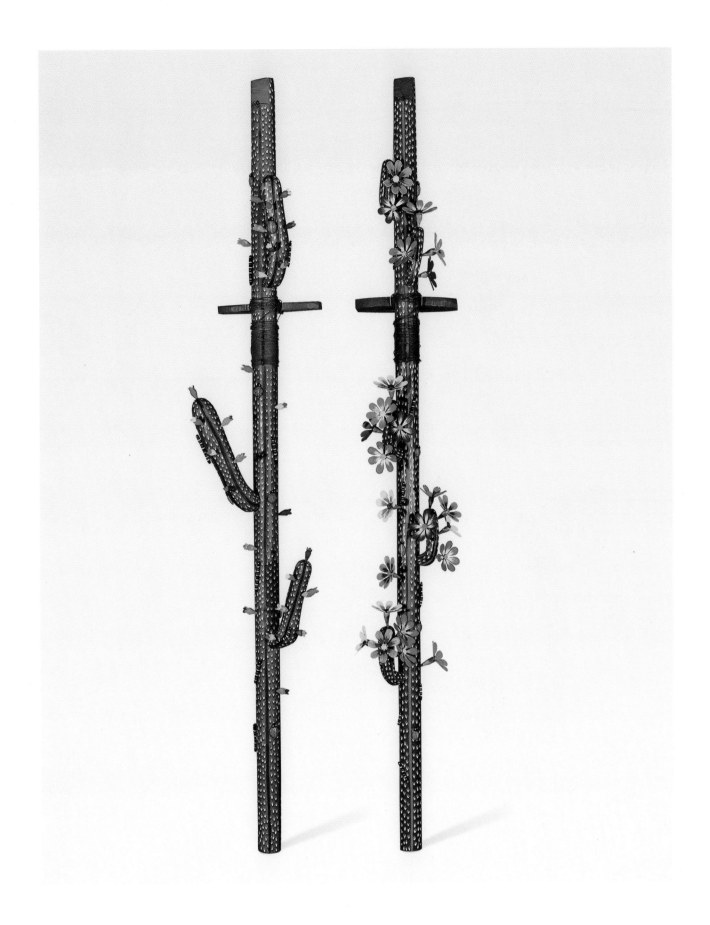

121

Cactus, 2012
carved and painted wood made following alebrije traditions
of San Martín Tilcajete, Oaxaca, unique
each 79 × 9½ × 13 in. / 200.7 × 24.1 × 33 cm

pp. 122–23: Festivities for San Pedro, Zaachila, Oaxaca (2012).
Collaboration with Los Zancudos de Zaachila and the Brooklyn Jumbies
Zaachila, Oaxaca.
Photo: Marco Pacheco

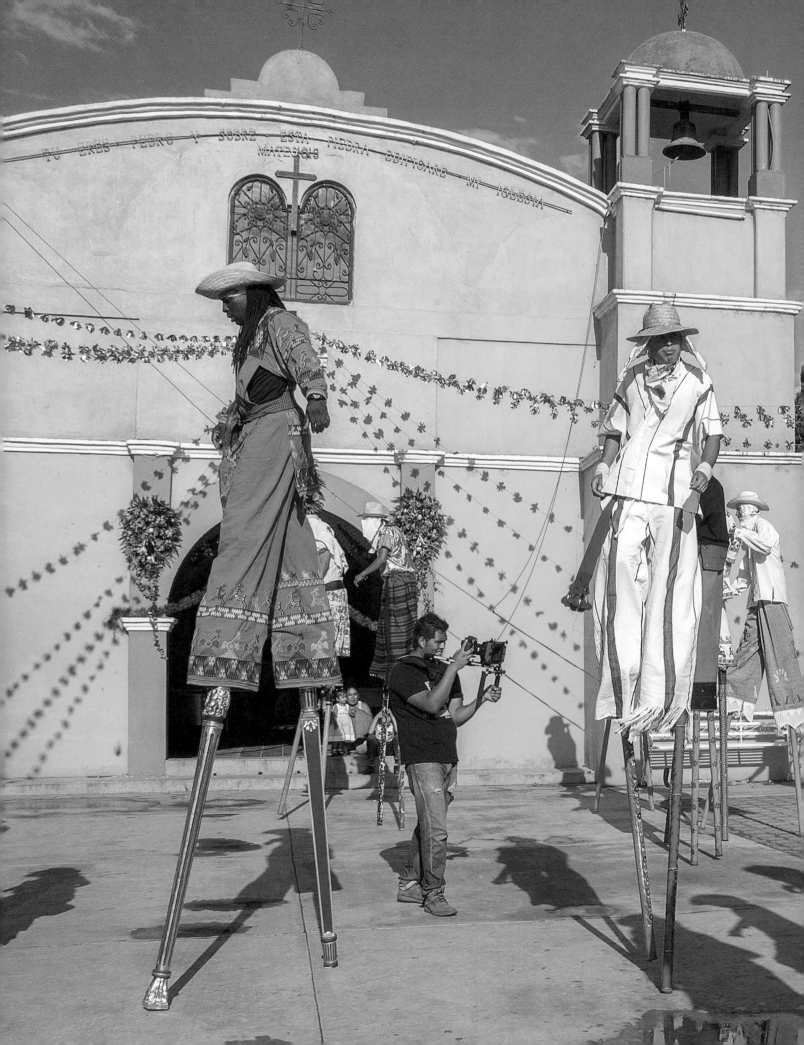

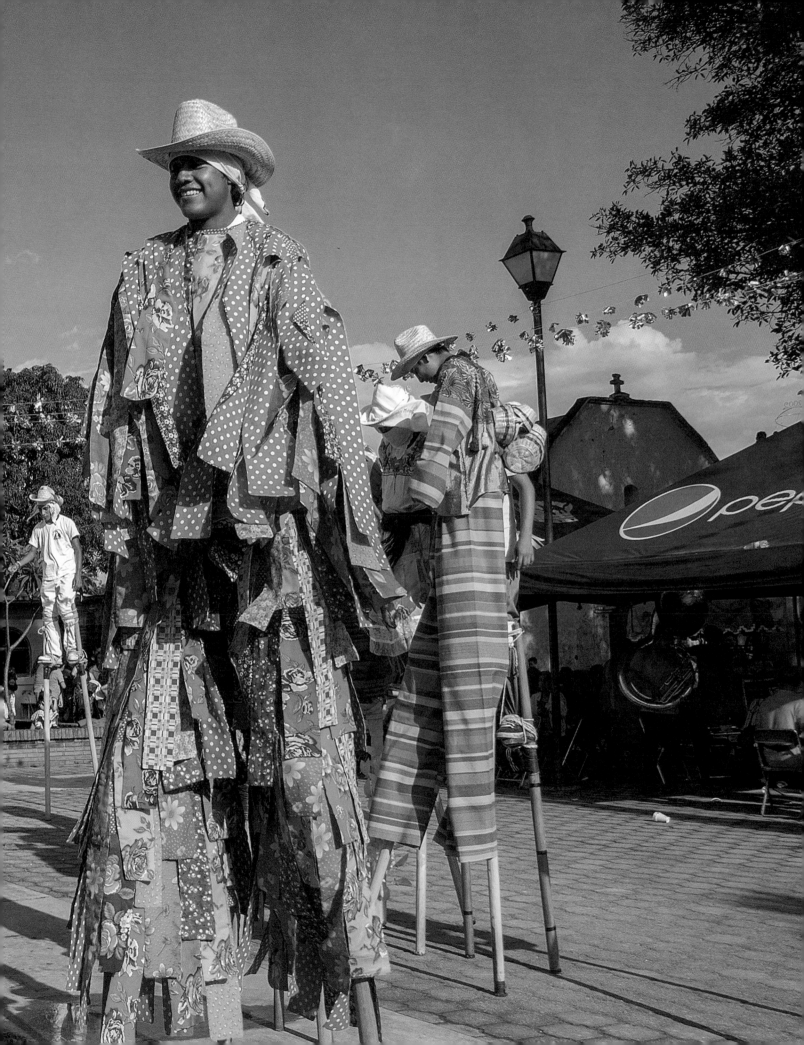

Procesión de Alebrijes, 2011–12
mixed media installation (23 characters)
dimensions variable

p. 126: *El venado azul*, 2011–12
Deer alebrije: carved and painted wood, cotton fabric,
cotton thread, and escapularios from Teotitlán del Valle, Oaxaca

p. 127: *Tlacololero*, 2011–12
Bull alebrije: carved and painted wood, assorted cotton fabrics,
cotton thread, and ixtle fiber

p. 128: *El gato Shaman*, 2011–12
Cat alebrije: carved and painted wood, assorted cotton fabrics,
and cotton thread

p. 129: *Mamá cochinita*, 2011–12
Piggie alebrije: carved and painted wood, cotton fabric,
and cotton thread

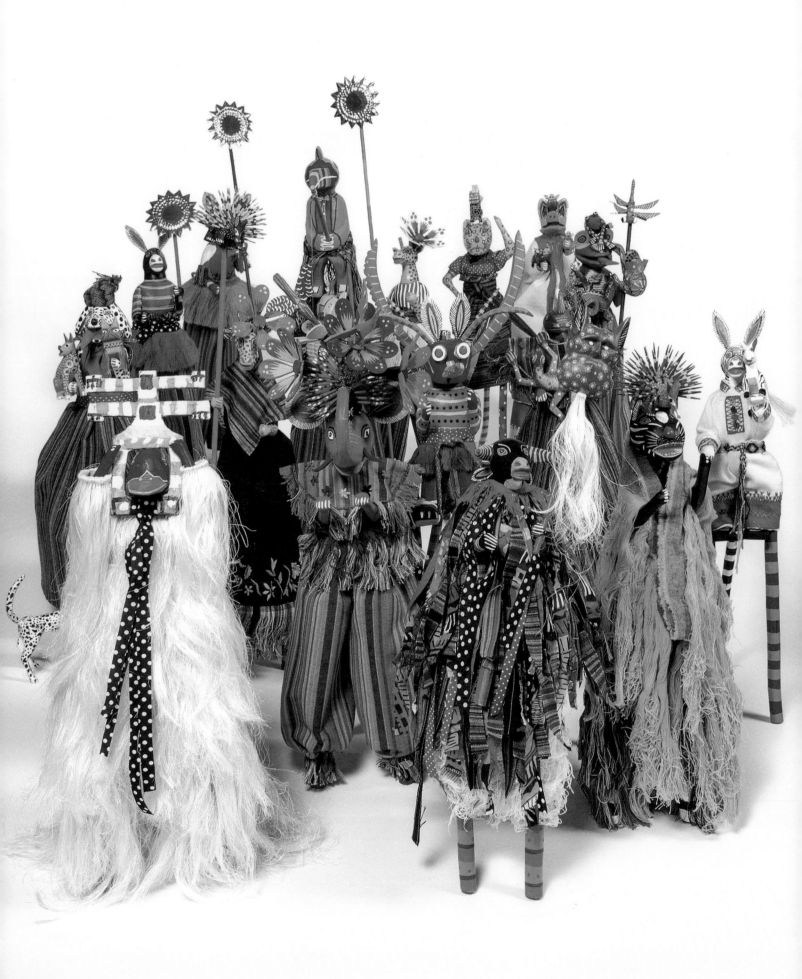

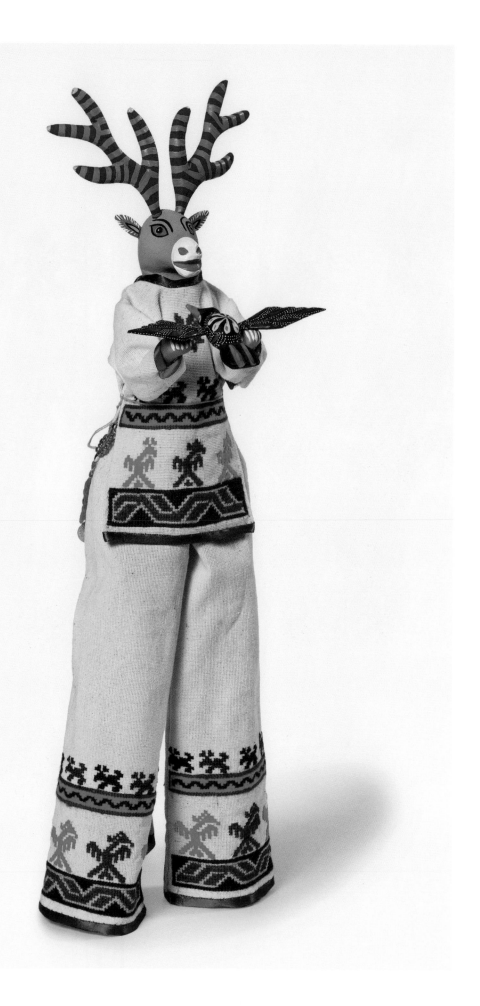

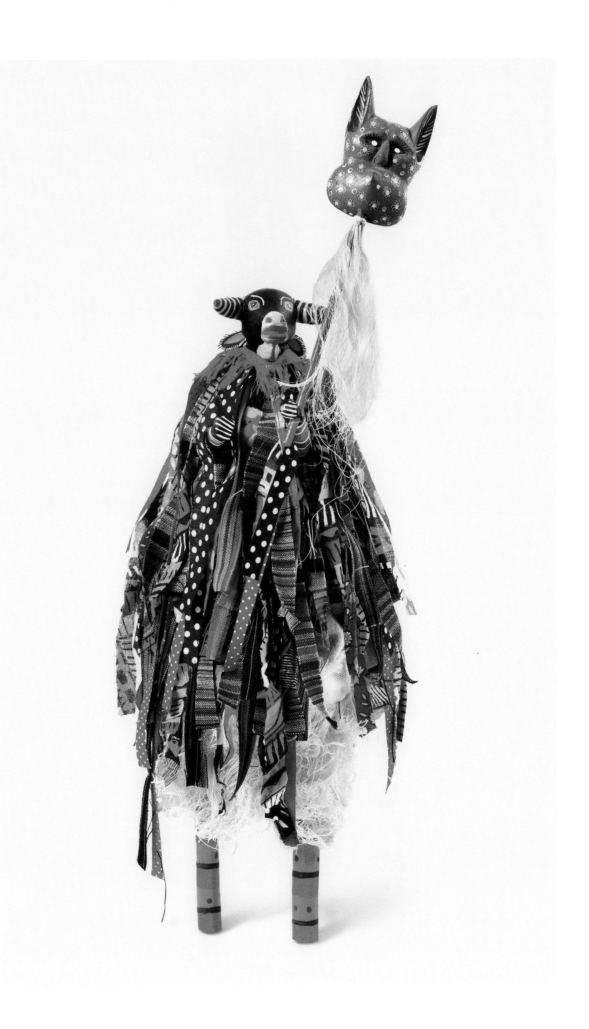

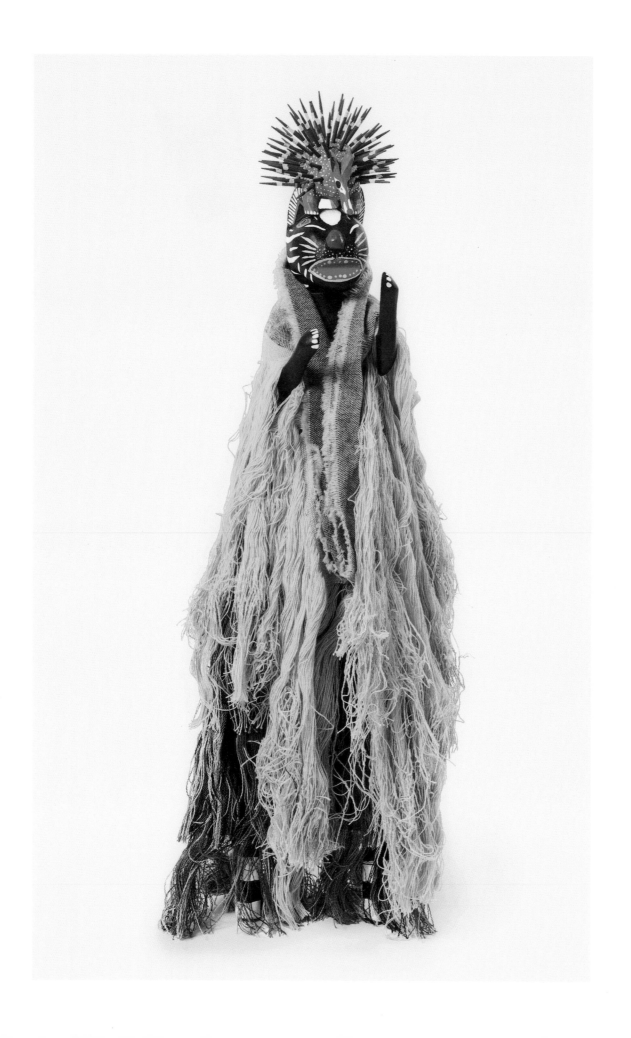

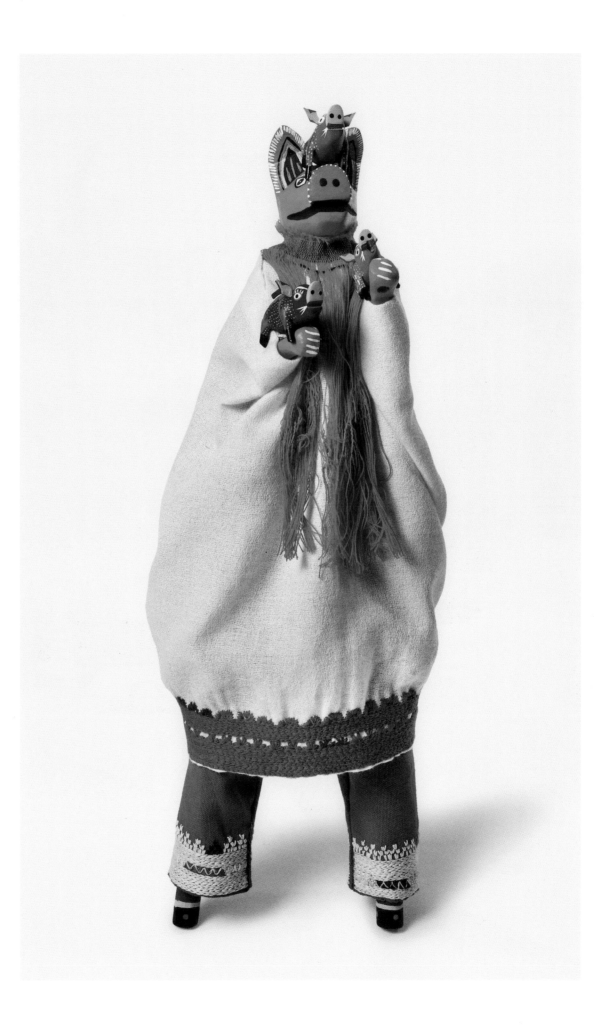

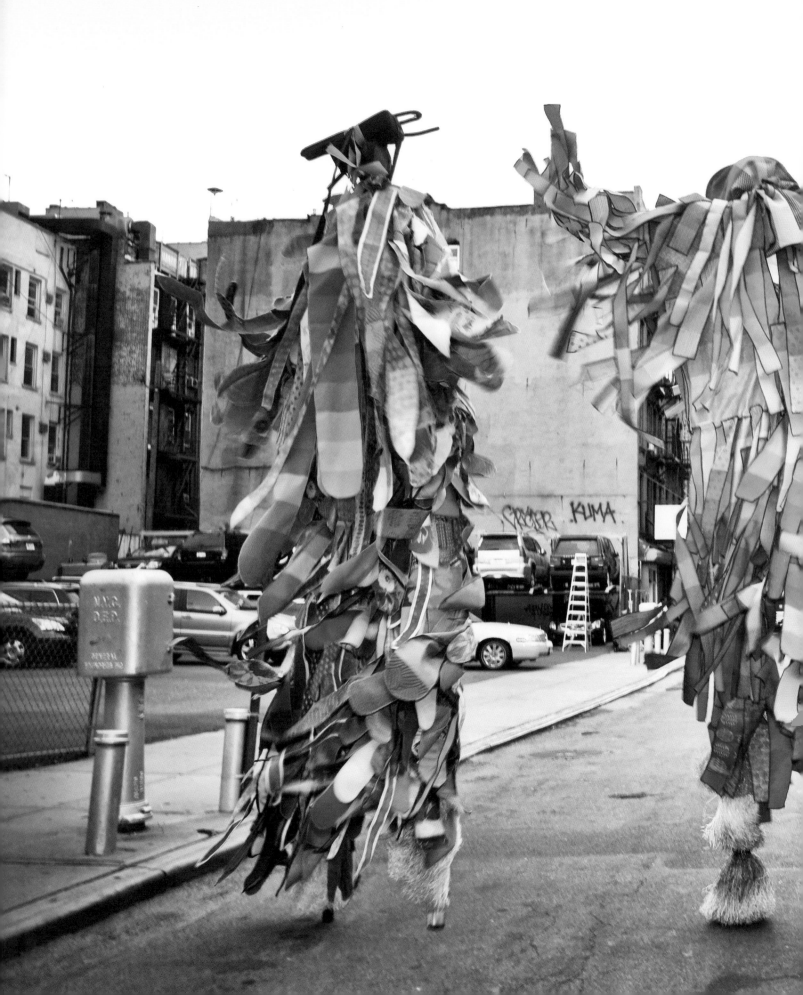

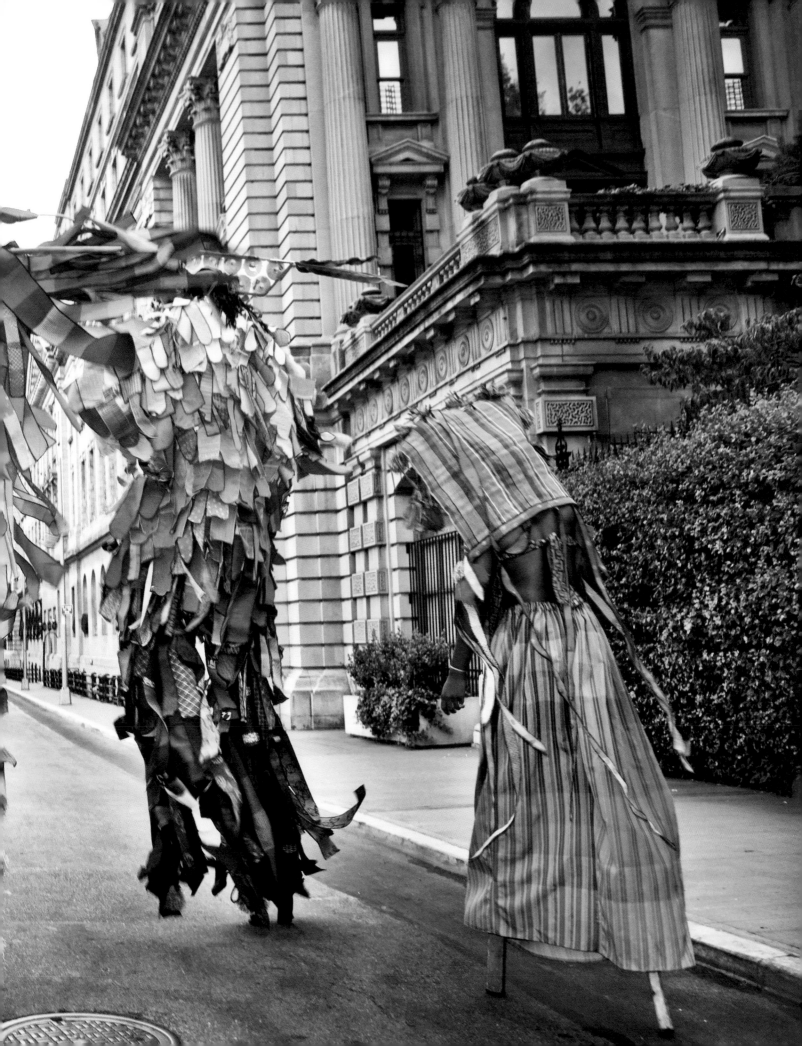

pp. 130–31: *Intervention: Soho/Chinatown* presented in
collaboration with the Brooklyn Jumbies, New York (2008).
Photo: Frank Veronsky

opposite: *Happy Suit*, 2008
repurposed textiles and thread, unique
128 × 85 × 6 in. / 325.1 × 215.9 × 15.2 cm

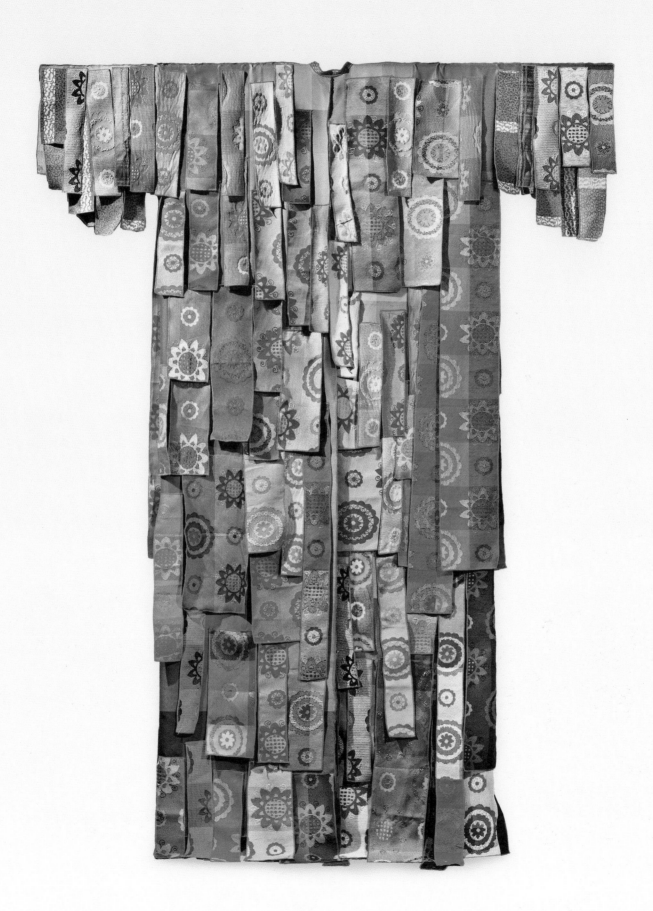

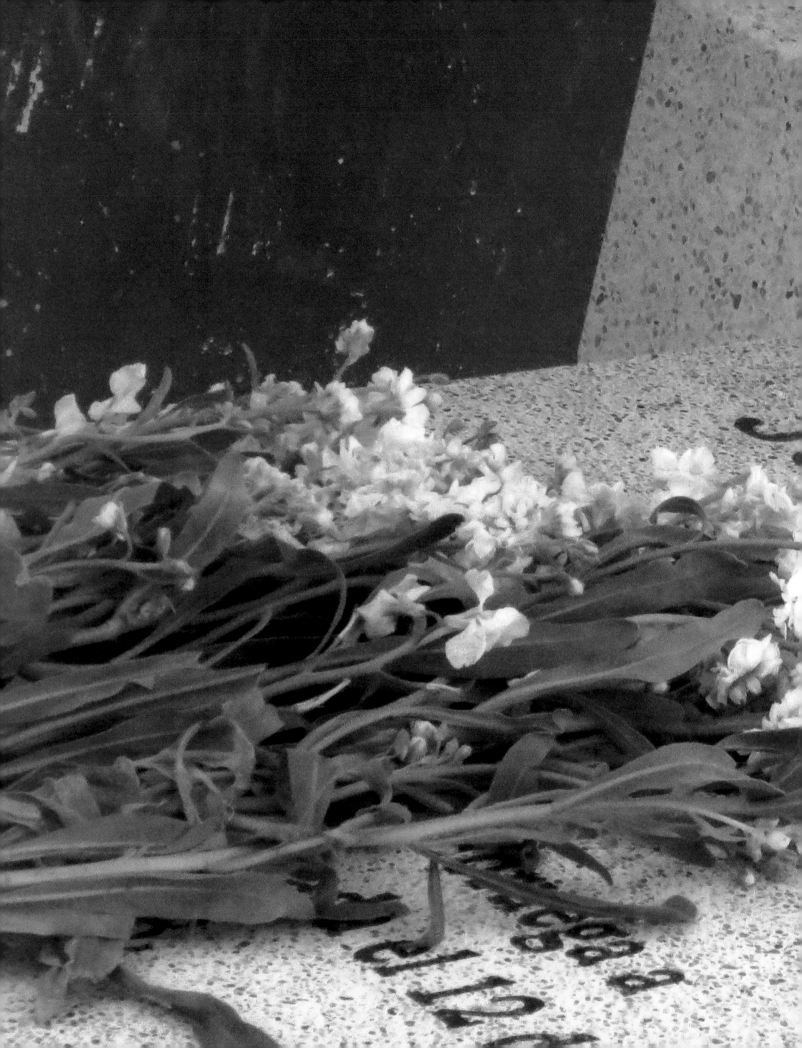

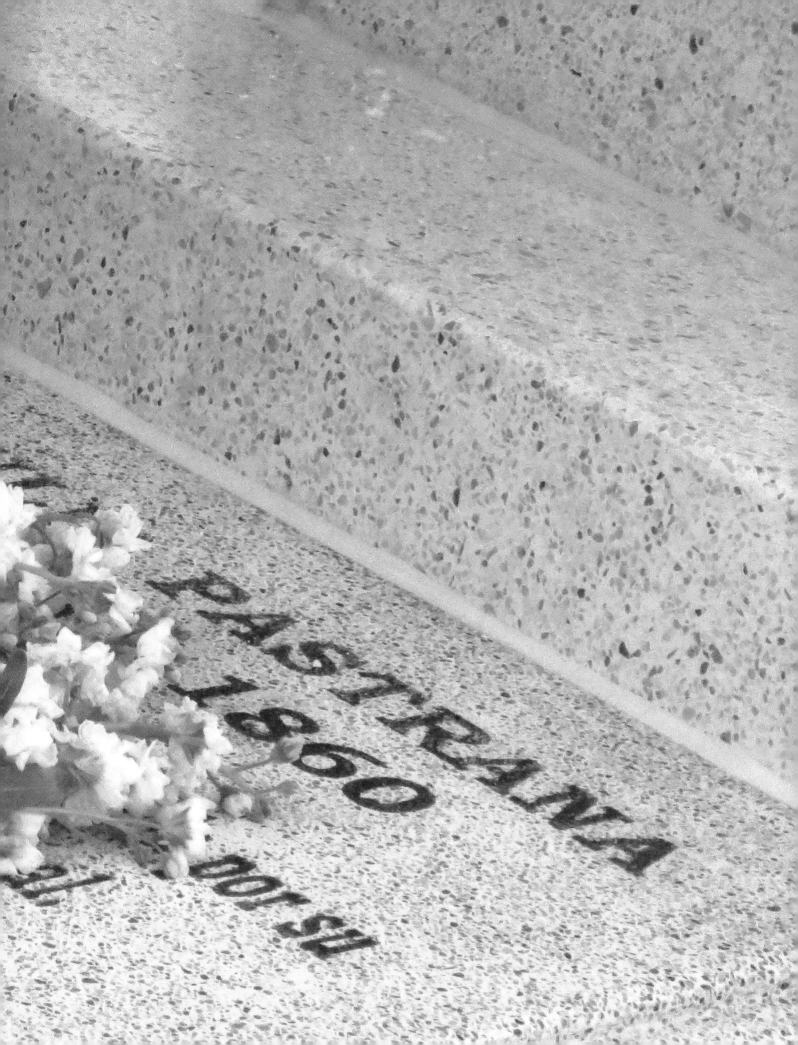

pp. 134–35: Detail of Julia Pastrana's Grave (2013).
Photo: Dignicraft

opposite: *Julia Pastrana descansa en paz*, 2013
pastel frottage on handmade rice paper
diptych, each 20 × 30 in. / 50.8 × 76.2 cm

pp. 138–39: *Julia Pastrana, 8 Portraits*, 2012
abaca and human hair on handmade pigmented cotton linter paper,
each a variation from a series of 11
each 18 × 12 in. / 45.7 × 30.5 cm

JULIA PASTRANA
1834 - 1860

Artista sinaloense reconocida por su
trayectoria internacional.

Repatriada de Oslo, Noruega a
Sinaloa, México. Sepultada el 12 de
febrero de 2013

Julia Pastrana, descansa en paz.

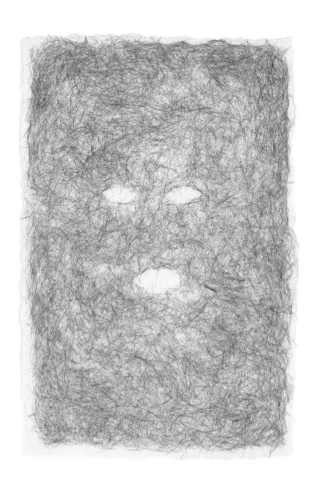
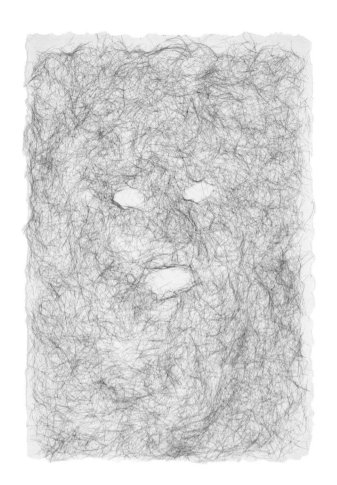

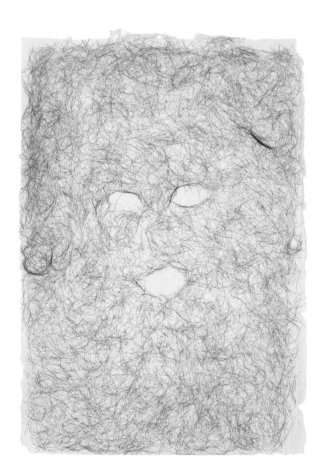
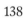

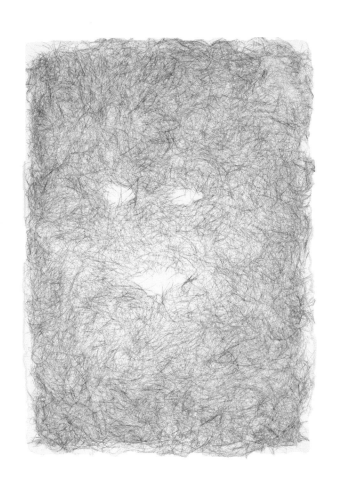

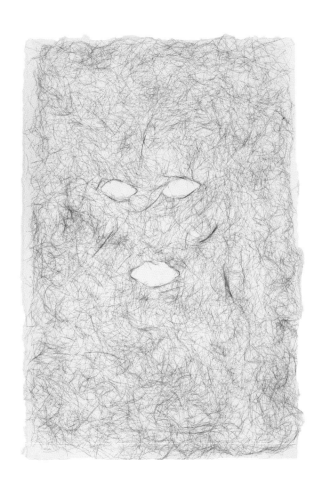
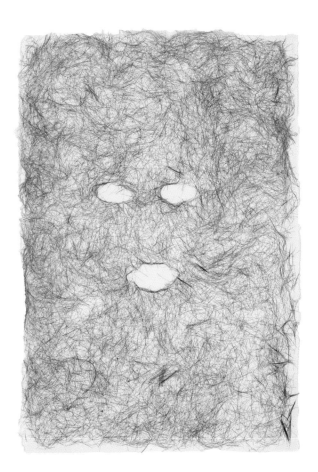

Julia Pastrana, Bienvenida a casa, 2012
handmade paper from pink cotton, stenciled and pulp painted
with pigmented flax, variation from a series of 11
23¾ × 18 in. / 60.3 × 45.7 cm

141

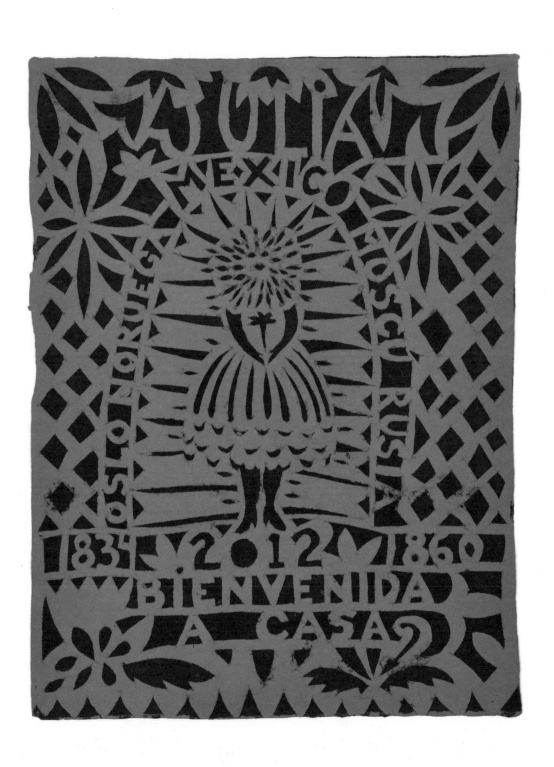

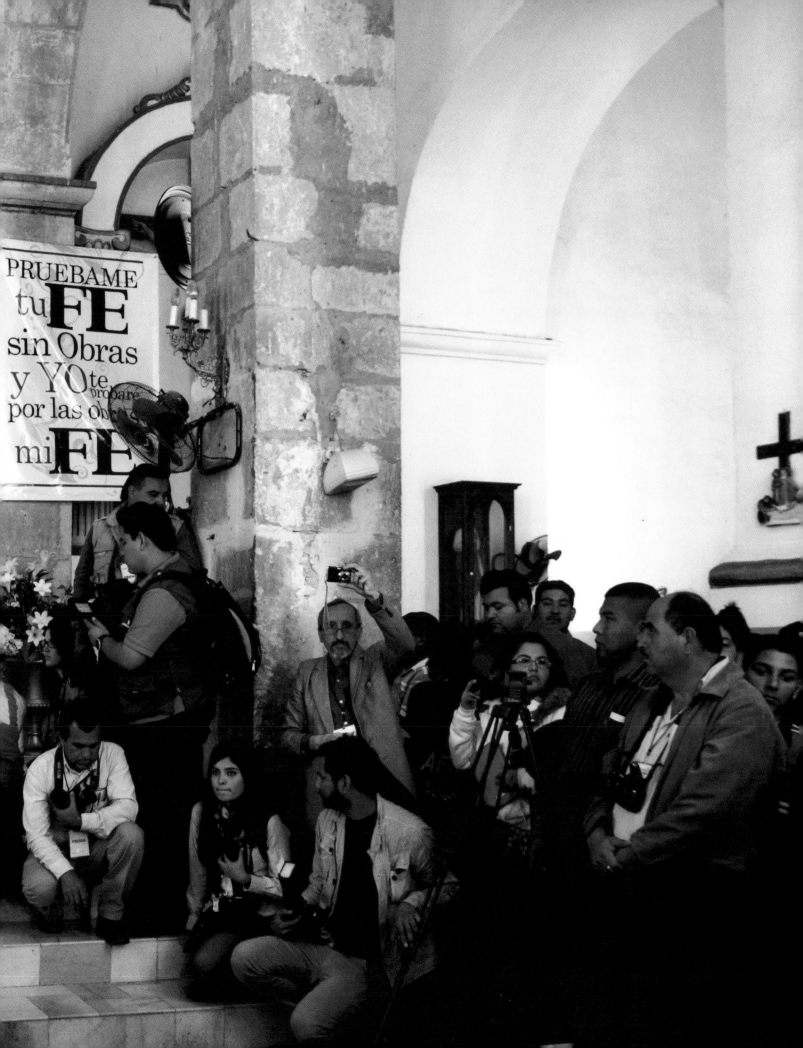

Biography

Born in 1958 in Mexico City, Laura Anderson Barbata is a transdisciplinary artist, performer, writer, and educator who lives and works between New York and Mexico City. Since 1992 Anderson Barbata has worked primarily in the social realm, initiating projects in the Venezuelan Amazon, Trinidad and Tobago, Mexico, Norway, and the United States. Among them is the ongoing *The Repatriation of Julia Pastrana*, begun in 2005, which resulted in the removal of the project's titular figure's body from the Schreiner Collection in Oslo, Norway and its successful repatriation and burial in Sinaloa, Mexico, Pastrana's birth state. The project continues with Anderson Barbata's production of related artworks, publications, zines, and performances.

Anderson Barbata is also known for her project *Transcommunality* (2001-present), presented in collaboration with stilt dancers, artists, and artisans from Mexico, New York, and the Caribbean. *Transcommunality* has been staged at various museums, schools, and other public spaces both as exhibitions and performance "Interventions." Among them are Columbia University, New York (2023); The Watermill Center, Water Mill (2021); Newcomb Art Museum, New Orleans (2021); MUCA Roma, UNAM, Mexico (2020); BRIC Arts | Media House, Brooklyn (2019); The Kennedy Center for the Performing Arts, Washington, D.C. (2019); Isabella Stewart Gardner Museum, Boston (2017, 2018); Rutgers University, New Brunswick (2017); United Nations Plaza, New York (2017); University of Wisconsin, Madison (2015); Museo Textil de Oaxaca, Mexico (2012, 2016); The Modern Art Museum of Fort Worth, Texas (2008); and the Museum of Modern Art, New York (2007).

As of 2023, Anderson Barbata has been awarded numerous grants, prizes, residencies, and teaching positions, including: CAA Board of Directors (2018-present); Honorary Fellow of LACIS (the Latin American, Caribbean, and Iberian Studies Program), University of Wisconsin, Madison (2015-present); CAA Vice President for Diversity and Inclusion (2023-24); Artist Fellow, National Arts Club, New York (2022-23); *The Experience of the Common* for CLASSROOM, presented by LA ESCUELA___ and the School of Architecture and Design PUCV, Chile (2022); CAA Vice President for Annual Conference and Programs (2021-22); Artist in Residence, Bellagio Center, Rockefeller Foundation, Italy (2019); Defense of Human Rights Award from the Instituto de Administración Pública de Tabasco, Mexico (2017); Estelle Lebowitz Endowed Visiting Artist in Residence, The Center for Women in the Arts and Humanities, Rutgers University, New Brunswick (2016-17); Artist in Residence, Isabella Stewart Gardner Museum, Boston (2016); Anonymous Was a Woman Award (2016); Fellow of the Thyssen-Bornemisza Art Contemporary TBA21 Academy (2015); Artist in Residence, Interdisciplinary Arts Department, Columbia College Chicago Center for Book and Paper, Chicago (2012); Miembro del Sistema Nacional de Creadores, FONCA-CONACULTA, Mexico (2014-17 and 2010-13); and Professor at the Escuela Nacional de Escultura, Pintura y Grabado La Esmeralda of the Instituto Nacional de Bellas Artes, Mexico (2010-15).

Anderson Barbata has also been invited to give talks and lectures. In 2023, Anderson Barbata gave an artist talk accompanying *Chosen Memories: Contemporary Latin American Art from the Patricia Phelps de Cisneros Gift and Beyond*, Museum of Modern Art, New York. Other artist talks have been held at Vienna Tanzquartier, Center of Performing Arts, Vienna (2023); RISD Museum, Providence (2023); Museo Rufino Tamayo, Mexico City (2023); Boston University, Boston (2022); Universidad Nacional Autónoma de México, Mexico City (2022); the Reva and David Logan Symposium on the Artist Book, Legion of Honor Museum, San Francisco (2021); Los Angeles County Museum of Art, Los Angeles (2019); and Bard College, Annandale-On-Hudson (2019). Anderson Barbata was also the Commencement Speaker at CENTRO, Mexico City (2020) and the Keynote Speaker at the North American Textile Conservation Conference, Smithsonian Museum of the American Indian, New York (2015).

Institutional Collections

Adam and Sophie Gimbel Design Library,
 Parsons School of Design, The New School,
 New York, New York
Arizona State University Polytechnic Campus,
 Mesa, Arizona
Artists' Books Collection, Library of Congress,
 Washington, D.C.
Casa del Lago UNAM, Mexico City, Mexico
Centro Cultural Arte Contemporáneo,
 Mexico City, Mexico
Cotsen Library Collection, Princeton University,
 Princeton, New Jersey
Franklin Furnace Archive, Brooklyn, New York
Fundaçao Bozano-Simonsen, Río de Janeiro, Brazil
Colección Patricia Phelps de Cisneros
Galería Metropolitana UAM, Mexico City, Mexico
Getty Research Institute, Los Angeles, California
Green Library, Stanford University, Stanford, California
Gimbel Library, Parsons School of Design,
 New York, New York
Howard-Tilton Memorial Library, Tulane University,
 New Orleans, Louisiana
Instituto de Artes Gráficas de Oaxaca, Oaxaca, Mexico
Instituto Nacional de Bellas Artes y Literatura,
 Mexico City, Mexico
John M. Flaxman Library, School of the Art Institute
 of Chicago, Illinois
Kohler Art Library, University of Wisconsin,
 Madison, Wisconsin
Landesbank Baden-Württemberg, Stuttgart, Germany
The Metropolitan Museum of Art, New York, New York
Museo de Arte Abstracto Manuel Felguérez,
 Zacatecas, Mexico
Museo de Arte Alvar y Carmen T. Carillo Gil,
 Mexico City, Mexico
Museo de Arte Contemporáneo de Monterrey,
 Nuevo León, Mexico
Museo de Arte Moderno, Mexico City, Mexico
Museo de Monterrey, Monterrey, Nuevo León, Mexico
Museo Jareguía, Navarra, Spain
Museu Oscar Niemeyer, Curitiba, Brazil
Museum of Contemporary Art, San Diego, California
Museum of Latin American Art, Long Beach, California

Museum of Modern Art, New York, New York
Penn University Library, University of Pennsylvania,
 Philadelphia, Pennsylvania
Raúl Rangel Frías Biblioteca, Universidad Autónoma
 de Nuevo León, Monterrey, Mexico
Richter Library, University of Miami, Miami, Florida
San Antonio Museum of Art, San Antonio, Texas
Spencer Collection, The Miriam and Ira D. Wallach
 Division of Art, Prints and Photographs,
 New York Public Library, New York, New York
Thyssen-Bornemisza Art Contemporary
Tozzer Library, Harvard University,
 Cambridge Massachusetts
Universidad Nacional Autónoma de México,
 Mexico City, Mexico
University of California, Santa Barbara Library,
 Isla Vista, California
USC Fisher Museum of Art, Los Angeles, California

Timeline of Julia Pastrana

1834

Julia Pastrana is an Indigenous Cahita woman believed to have been born in Ocoroni, a small village in the western Sierra Madre region of the State of Sinaloa, Mexico. Born with hypertrichosis terminalis and severe gingival hyperplasia, Pastrana's face and body are covered with thick hair and she has an overdeveloped jaw.

1834–5?

The details of Pastrana's childhood are uncertain. According to Ricardo Mimiaga's oral history, her mother dies during her infancy with her uncle becoming her caretaker soon after. He sells her to a traveling circus.

185?–54

Pastrana lives in Culiacán in the home of Pedro Sánchez (the governor of Sinaloa from 1836-37). During this time, it is believed that she begins her training as a mezzo-soprano and dancer. She also becomes fluent in English and French, in addition to Spanish and her native indigenous language, Cahita. Pastrana leaves the governor's house after she is sold to Francisco Sepulveda, the administrator of maritime customs in Mazatlán, Mexico. According to Irineo Paz, Sepulveda partners with the governor of Sinaloa and an American businessman, Theodore Lent, to showcase Pastrana in the United States.

1854–55

Pastrana performs in Guadalajara, Mexico, and the United States.

1855

From evidence found in archival documents, it is possible that Pastrana accompanies Sepulveda from Veracruz to New Orleans to meet Lent. Upon her arrival, Lent secretly convinces Pastrana to marry him and becomes her manager. Lent subsequently organizes exhibits of her in New York, Cleveland, Baltimore, Boston, and Canada.

1854–58

Lent bills Pastrana as *The Ugliest Woman in the World, the Nondescript, the Hirsute, the Ape Woman, the Female Hybrid, the Wonderful Hybrid, Bear-woman*, and *Baboon Lady*, among other sobriquets. They travel to London and throughout Europe, presenting shows in which Pastrana dances and sings opera arias. Doctors visit and examine her, and she becomes the subject of writings by Francis T. Buckland and Charles Darwin.

1857

Gartenlaube (a newspaper in Leipzig, Germany) publishes an interview with Pastrana.

1859

Pastrana becomes pregnant by Lent.

1860

Pastrana and Lent travel to Moscow. On March 20th, she gives birth to a baby boy who is diagnosed with the same condition as her. The infant dies thirty-five hours later. Complications during childbirth keep Pastrana hospitalized, and Lent sells tickets to view her in her hospital bed. On March 25th, she dies of puerperal metro peritonitis. Lent sells the bodies of his wife and child to Dr. Sokolov of the University of Moscow, who was known for developing embalming techniques.

1862

Lent visits the hospital at the University of Moscow. When he sees the embalmed bodies of Pastrana and her son, he demands that they be returned to him. The request is denied. Lent contacts the United States Consulate to reclaim them, and, with their intervention, he is successful. He encloses Pastrana and her child inside a glass case and begins to exhibit them throughout Europe. He experiences greater commercial success than when she was exhibited alive.

1864

Lent meets Marie Barthel, a young bearded woman from Karlsbad, Germany. He changes her name to Zenora Pastrana. Barthel becomes part of the exhibition, which presents the bodies of Julia Pastrana and her baby as Zenora's sister and nephew. Lent's economic successes continue.

1884

Theodore Lent dies in a psychiatric hospital in Saint Petersburg, Russia. Barthel inherits the bodies of Pastrana and her son and continues to exhibit them.

1921

Marie Barthel sells Pastrana and her son to the Norwegian Haakon Jaeger Lund, who exhibits them in Oslo, Norway. Later, his son, Hans Jaeger Lund, takes the bodies on tour.

1943

Shortly before World War II, the German diplomat in charge of Oslo's medical department orders for the bodies of Pastrana and her son be confiscated and sent to Berlin. Lund declines and takes them on tour throughout the Nordic countries.

1953

The bodies of Pastrana and her child are stored in Linkönping, Sweden.

1954

Hans Jaeger Lund dies, and his son, Bjorn, inherits the bodies of Julia Pastrana and her baby. They are subsequently stored in a warehouse in Oslo.

1971

Pastrana and her son are exhibited in Norway multiple times as part of the touring Tivoli Fair.

1971–72

Pastrana and her son are taken on tour to the United States and exhibited in fairs.

1973

Sweden and Norway pass laws that prohibit the exhibition of human bodies. The Bishop of Oslo requests that the bodies be confiscated and buried in a Catholic ceremony.

1976

Bjorn Lund puts Pastrana and her son in storage in Oslo. Thieves break into the warehouse and throw the mummified infant into a field, where it is eaten by rodents. Pastrana's arm is ripped from her body. It is later found in a dumpster and taken to the police.

1979

Lund's warehouse is vandalized again and Pastrana's body disappears.

1988

Dr. Jan Bondeson finds Pastrana's body in a janitorial closet in the basement of the Institute of Forensic Medicine at the Rikshospitalet in Oslo. Her body is restored, and she is kept at the Institute.

1994

The University of Oslo and other organizations discuss the future of Julia Pastrana. Voting is in favor of burying Pastrana, only a Dr. Per Holck opposes. Shortly after the vote, the Royal Ministry of Health and Church Affairs orders that Julia Pastrana remain in custody of the Schreiner Collection in the Department of Anatomy at the University of Oslo for research purposes. The Director of the Schreiner Collection is Dr. Per Holck.

1996–2005

Jan Bondeson, Rosemarie Garland-Thompson, and numerous other authors publish studies on Pastrana in Europe and the United States. By contrast, there are only a few studies on Pastrana published in Mexico.

2003

Laura Anderson Barbata becomes familiar with the life story of Julia Pastrana after her sister Kati Culebro invited her to collaborate on the costume design for a play based on Pastrana (produced by Amphibian Stage in New York City). Culebro sends a letter to the Mexican Embassy in Norway requesting the repatriation and burial of Pastrana. She gathers hundreds of signatures in support. The letter is sent, but no reply is received.

2004

The Office of Contemporary Art (OCA), Oslo invites Anderson Barbata to meet with Sami communities in northern Norway. She makes contact with institutions, academics, scholars, artists, politicians, and activists from and for the Sami communities. She learns that the Schreiner Collection, where Pastrana is kept, possesses hundreds of illegally obtained Sami skulls.

2005

The OCA awards Anderson Barbata with an artist residency in Norway. She proposes a project on Julia Pastrana during her residency, beginning correspondence with the University of Oslo, Dr. Per Holck, anthropologists, sociologists, Sami scholars, intellectuals, historians, artists, and the University's ethics committee. The National Committee for Research in the Social Sciences and the Humanities (NESH) informs Anderson Barbata that they are forming a new Board to evaluate cases involving human remains. They agree that she can bring Julia Pastrana to the Board as the first case for review.

2005

Anderson Barbata publishes an obituary for Julia Pastrana in the Oslo newspaper, which states that there will be a Catholic ceremony (the faith that Pastrana practiced in her lifetime) in her honor. With the aid of Christiane Erharter, Anderson Barbata organizes a mass in Pastrana's memory at St. Joseph Chapel in Oslo. The mass is the first humanitarian gesture toward Pastrana, and it is attended by hundreds of people, many of whom are circus performers, who bring her flowers.

2005

The new Board for the Evaluation of Human Remains under NESH is officially formed. Anderson Barbata formally requests that they evaluate the case for Julia Pastrana's repatriation and burial in Mexico.

2007

The committee informs Anderson Barbata that the case of Pastrana will be reopened. The official document stating this is lost by the United States Postal Service, but is recovered and delivered to Anderson Barbata, damaged, one year later.

2007–11

In an effort to locate Julia Pastrana's relatives, Anderson Barbata consults scientists specializing in genetics. After extensive research, it becomes clear that a moral and ethical argument is a more feasible justification for Pastrana's repatriation than finding her relatives, since DNA samples are not available. Anderson Barbata meets Ricardo Mimiaga, a historian from Sinaloa who has researched the life of Pastrana. Together they search for related documents, such as her certificates of birth and baptism.

2011

Silvia Gámez, a reporter for Mexico's *Reforma* newspaper, discovers the story of Julia Pastrana, as well as Laura Anderson Barbata's involvement in her repatriation. Gámez begins correspondence with Anderson Barbata, the University of Oslo, and Norway's Ministry of Health, in addition to scientists and historians in Mexico. She publishes her findings, and the story is picked up by hundreds of news sites around the world.

2012

Norway's Ministry of Health recognizes that scientific research has never been conducted on Pastrana's body, nor have they received any official requests for Pastrana to be buried. Anderson Barbata discusses the creation of a ceremonial pre-Hispanic huipil for Pastrana's burial with Remigio Mestas in Oaxaca. Francisca Palafox, a master weaver from Oaxaca, makes the *huipil* and *enredo* textiles utilizing natural cotton, coyuchi, caracol, and human hair.

March 14, 2012

In Culiacán, Anderson Barbata has an audience with the Governor of Sinaloa, proposing the repatriation of Julia Pastrana to her native state for burial.

April 16, 2012

Mario López Valdez, the Governor of Sinaloa, joins Anderson Barbata's in her efforts, sending a letter to NESH petitioning for the return of Julia Pastrana's body. The Governor's letter is accompanied by a letter from Anderson Barbata, which includes the moral, ethical, and social justifications for Pastrana's repatriation and burial.

May 8, 2012
In Oslo, NESH meets to evaluate the letters calling for Julia Pastrana's repatriation.

June 4, 2012
NESH responds to the petition with a recommendation that Julia Pastrana be repatriated for burial in accordance with her religious faith. Both the University of Oslo and its Institute of Basic Medicine receive the recommendation and agree to the repatriation.

June–December 2012
Anderson Barbata contacts the institutions involved in the repatriation of Julia Pastrana, including the Office of Foreign Affairs of Mexico, the Embassy of Mexico in Belgium (which is also responsible for Norway), the University of Oslo, the Ministry of Health of Norway, Albin International Repatriation Services Ltd., funerary services in Oslo, Mexico City, and Culiacán, the Institute of Culture of Sinaloa, and the office of the Governor of Sinaloa.

January 2013
Anderson Barbata initiates "A Flower for Julia," an international call for flowers to symbolically welcome Julia Pastrana home and give closure to her long journey on the day of her burial.

February 7, 2013
Anderson Barbata and the forensic anthropologist Nicholas Márquez-Grant from the University of Oxford act as witnesses confirming that Julia Pastrana's body is sealed in her coffin. In the Chapel at Rikshospitalet, Oslo University Hospital, a private ceremony takes place marking the transfer of custody of Pastrana from the Schreiner Collection to the Government of Mexico. Anderson Barbata represents the State of Sinaloa. Artists, academics, and activists attend the ceremony.

February 8–10, 2013
Julia Pastrana is transported from Oslo to Mexico in a sealed coffin. The body arrives in Culiacán, Sinaloa. Anderson Barbata is present and verifies that Pastrana is in the coffin. The coffin is not opened again.

February 12, 2013
Julia Pastrana's coffin is transported from Culiacán to Sinaloa de Leyva. Pastrana is welcomed with official ceremonies and a funeral mass, then taken to the municipal cemetery following local traditions. Inside her coffin, Pastrana is covered with pre-Hispanic ceremonial *huipil* garments and a photograph of her child rests on her chest. As music plays, Pastrana's coffin is covered with flowers and buried. Her tomb is enclosed in concrete walls that are more than a meter thick, protecting Pastrana from vandals and guaranteeing that she will never be removed from her resting place. Julia Pastrana's tomb is then covered with thousands of flowers that have arrived from all over the world.

New research is continually uncovering additional information. For the most up-to-date information, we invite you to consult juliapastranaonline.com.

Appendix

[p. 108] *Rolling Calf*, 2015
assorted indigo dyed textiles on cardboard
90 × 23 × 26 in. / 228 × 58 × 66 cm
Installed in the artist's Brooklyn studio (2016).
Photo: Dora Somosi

[p. 109] *Indigo Queen*, 2015
handmade indigo-dyed cotton from Burkina Faso, assorted
cotton textiles, chest piece from Burkina Faso, sequins, raw silk,
dyed corn leaf flowers, paper, and cotton thread, unique
78 × 38 × 38 in. / 198 × 96 × 96 cm
Installed in the artist's Brooklyn studio (2016).
Photo: Dora Somosi

[pp. 110–11] *Reina Nyame* in *Osebo's Drum: A West African Tale* (2005)
assorted wax print textiles from West Africa, wood, cane,
fiberglass, mesh, mirrors, papier-mâché, and paint, unique
123¼ × 82⅝ × 82⅝ in. / 313 × 210 × 210 cm
Reina Nyame in *Osebo's Drum: A West African Tale*, 2005
Practice for Junior Carnival Parade with Keylemanjahro Moko
Jumbies, Cocorite, Port of Spain, Trinidad and Tobago.
Portrayed by Krystal Folkes.
Photo: Stefan Falke

[p. 113] *Reina Nyame*, 2005–07
assorted wax print textiles from West Africa, wood, cane,
fiberglass, mesh, mirrors, papier-mâché, and paint, unique
123¼ × 82⅝ × 82⅝ in. / 313 × 210 × 210 cm

[p. 114] *Columnas Novohispanas*, 2012
carved and polychromed cedar wood with gold and silver
leaf insertions, oil paint, and mirrors, made following the
Novohispano retablos tradition, unique
each 85¾ × 12 × 6 in. / 217.8 × 30.5 × 15.2 cm
Collaboration with conservator Oscar Vázquez.
Photo: Stefan Hagen

[p. 115] Laura Anderson Barbata preparing for an intervention with
the Brooklyn Jumbies, Teotitlán del Valle, Oaxaca (2012).
Photo: Marco Pacheco

[p. 116] *Jícaras*, 2012
carved and tinted gourd mosaics on wood, made using traditional
techniques from the Afro-Mexican coast of Oaxaca, unique
each 79 × 6 × 11 in. / 200.7 × 15.2 × 27.9 cm
Collaboration with artisans Don José Mendoza (stilts)
and Olegario Hernández (decoration).
Photo: Stefan Hagen

[p. 117] *Puerco espín*, 2012
carved and painted wood made following *alebrije* traditions
of San Martín Tilcajete, Oaxaca, unique
each 79½ × 8¼ × 10¾ in. / 201.9 × 21 × 27.3 cm
Collaboration with artisans Don José Mendoza (stilts)
and Jesús Sosa Calvo Juana Ortega Fuentes (decoration).
Photo: Stefan Hagen

[pp. 118–19] Festivities for San Pedro, Zaachila, Oaxaca (2012).
Collaboration with Los Zancudos de Zaachila and the Brooklyn
Jumbies, Zaachila, Oaxaca.
Photo: Marco Pacheco

[p. 120] *Vida y muerte*, 2011–12
carved and painted wood made following *alebrije* traditions
of San Martín Tilcajete, Oaxaca, unique
each 73 × 6 × 11 in. / 185.4 × 15.2 × 27.9 cm
Collaboration with artisans Don José Mendoza (stilts)
and Vicente Matías Fabián and Juana Venegas (decoration).
Photo: Stefan Hagen

[p. 121] *Cactus*, 2012
carved and painted wood made following *alebrije* traditions
of San Martín Tilcajete, Oaxaca, unique

each 79 × 9½ × 13 in. / 200.7 × 24.1 × 33 cm
Collaboration with artisans Don José Mendoza (stilts)
and Paula Sanchez and Florencio Fuentes (decoration).
Photo: Stefan Hagen

[p. 125] *Procesión de Alebrijes*, 2011–12
mixed media installation (23 characters)
dimensions variable
Photos: Marco Pacheco
consisting of:
– *Dogon Alebrije*, 2011–12
carved and painted wood, Oaxacan pita fiber hand-tied and sewn
onto cotton fabric
Collaboration between Master artisan Martín Melchor (alebrije)
and Laura Anderson Barbata (concept, clothing, and assemblage).
– *Alebrije Elefantita*, 2011–12
Elephant alebrije: carved and painted wood, cotton fabric,
and cotton embroidery
Collaboration between Master artisans Martín Melchor (alebrije),
Paula Sánchez and Florencio Fuentes (flowers, porcupine,
and hummingbirds), and Ernestina Gómez Gómez (embroidery)
and Laura Anderson Barbata (concept, sewing, and assemblage).
– *Mamá Jaguar con bebé llorando*, 2011–12
Jaguar alebrije: carved and painted wood, cotton fabric,
and cotton embroidery
Collaboration between Master artisans Martín Melchor (alebrije),
Paula Sánchez and Florencio Fuentes (baby jaguar), and Ernesti-
na Gómez Gómez (embroidery) and Laura Anderson Barbata
(concept, sewing, and assemblage).

[p. 127] *Tlacololero*, 2011–12
Bull alebrije: carved and painted wood, assorted cotton fabrics,
cotton thread, and ixtle fiber
Collaboration between Master artisans Martín Melchor (alebrije)
and Paula Sánchez and Florencio Fuentes (mask) and Laura
Anderson Barbata (concept, sewing, and assemblage).
Tucán pescando parado en la cabeza de su papá, 2011–12
Toucan alebrije: Carved and painted wood, assorted cotton
fabrics, and thread bracelet from San Juan Chamula
Collaboration between Master artisan Martín Melchor (alebrije)
and Laura Anderson Barbata (concept, sewing, and assemblage).
– *Mamá con perritos*, 2011–12
Dog alebrije: carved and painted wood, assorted cotton fabrics,
and thread bracelet from San Juan Chamula
Collaboration between Master artisans Martín Melchor (alebrije)
and Paula Sánchez and Florencio Fuentes (puppies) and Laura
Anderson Barbata (concept, sewing, and assemblage).

[p. 128] *El gato Shaman*, 2011–12
Cat alebrije: carved and painted wood, assorted cotton fabrics,
and cotton thread
Collaboration between Master artisans Martín Melchor (alebrije),
Paula Sánchez and Florencio Fuentes (porcupine) and Laura
Anderson Barbata (concept, sewing, and assemblage).

[p. 126] *El venado azul*, 2011–12
Deer alebrije: carved and painted wood, cotton fabric, cotton
thread, and escapularios from Teotitlán del Valle, Oaxaca
Collaboration between Master artisans Martín Melchor (alebrije),
Paula Sánchez and Florencio Fuentes (hummingbird),
and Julia Villa and Mariano Navarrete (Wixárika embroidery)
and Laura Anderson Barbata (concept, sewing, and assemblage).
– *Gallo y gallina*, 2011–12
Rooster alebrije: carved and painted wood, ixtle fiber,
and Oaxacan pita fiber
Collaboration between Master artisans Martín Melchor (alebrije),
Paula Sánchez and Florencio Fuentes (hen) and Laura Anderson
Barbata (concept, sewing, and assemblage).
– *Zebra y zebrita alebrijes*, 2011–12
Zebra alebrije: carved and painted wood, cotton fabric, cotton
thread, and ixtle fiber
Collaboration between Master artisans Martín Melchor (ale-
brije), Paula Sánchez and Florencio Fuentes (little zebra), and
Ernestina Gómez Gómez (embroidery) and Laura Anderson
Barbata (concept, sewing, and assemblage).

Marlborough New York

Douglas Kent Walla
CEO
dkwalla@marlboroughgallery.com

Sebastian Sarmiento
Director
sebastian@marlboroughgallery.com

Vesper Lu
Assistant to Sebastian Sarmiento
vesper@marlboroughgallery.com

Alexa Burzinski
Director
burzinski@marlboroughgallery.com

Nicole Sisti
Director
sisti@marlboroughgallery.com

Bianca Clark
Director of Graphics
clark@marlboroughgallery.com

Parks Busby
Graphics Assistant
busby@marlboroughgallery.com

Mariah Tarvainen
Design Director
tarvainen@marlboroughgallery.com

Meghan Boyle Kirtley
Administrator
boyle@marlboroughgallery.com

Greg O'Connor
Comptroller
greg@marlboroughgallery.com

Dibomba Jean-Marie Kazadi
Bookkeeper
kazadi@marlboroughgallery.com

Paul McDermott
Head Registrar
mcdermott@marlboroughgallery.com

Carly Johnson
Inventory Manager/Assistant Registrar
johnson@marlboroughgallery.com

Marissa Moxley
Archivist
moxley@marlboroughgallery.com

Isabel Wardlaw
Gallery Assistant
wardlaw@marlboroughgallery.com

John Willis
Warehouse Manager
willis@marlboroughgallery.com

Anthony Nici
Master Crater
nici@marlboroughgallery.com

Peter Park
Exhibition Coordinator
park@marlboroughgallery.com

Jeff Serino
Preparator
serino@marlboroughgallery.com

Brian Burke
Preparator
burke@marlboroughgallery.com

Matt Castillo
Preparator
castillo@marlboroughgallery.com

Published on the occasion of the exhibition
Laura Anderson Barbata: Singing Leaf
September 9 – October 28, 2023

Marlborough New York
545 West 25th Street
New York, NY 10001
+ 1 212 541 4900
marlboroughgallery.com

Editors: Alexa Burzinski, Nicole Sisti, Marissa Moxley
Design and Layout: Mariah Tarvainen
Printing and Binding: Graphiscan, Canada

First Edition
ISBN: 978-0-89797-455-4

$40.00
ISBN 978-0-89797-455-4

Marlborough